Royal Moro Armor from the Moroland Museum

field guide

*Ninth Edition
Volume #01*

Written by

Author/Publisher	Graphic Artist	Photographer	Legal Council
Bruce Jenkins	**Jess Holloway**	**Bruce Jenkins/**	**Frank Gannon**
Evelyn Jenkins		**Ben VerVer**	

ROYAL MORO ARMOR FROM THE MOROLAND MUSEUM by Bruce Jenkins

© 2018 by Moroland Museum. All rights reserved.

No part of this book may be reproduced in any written, electronic, recording, or photocopying form without written permission of the author or Moroland Museum.

Books may be purchased in quantity and/or special sales by contacting Moroland Museum online at:

www.morolandmuseum.com
morolandmuseum@gmail.com

Published by: Moroland Museum
Author & Photography by: Bruce Jenkins & Evelyn Jenkins
Graphic Artist by: Jess Holloway

First Edition

Printed in USA

This book is dedicated to
the people of the Philippines, their weapons and artifacts,
our families and to all our friends of Moroland.
God bless you all!

ROYAL COURT ARMOR of MOROLAND MUSEUM

TABLE OF CONTENTS

DESCRIPTION		LOCATION
King's Crown and Face Guard		FRONT COVER
Introduction		05
Historical Moro Tribe of the Philippines		06
Moro Royal Guards' Armor Full Set #1		09
Moro Royal Guards' Helmet	#01	10
Moro Royal Guards' Face Mask	#02	12
Moro Royal Guards' Vest	#03	14
Moro Royal Guards' Groin Protector	#04	16
Moro Royal Guards' Knee Guards	#05	18
Moro Royal Guards' Rectangle Shield	#06	20
Moro Royal Guards' Knife	#07	22
Moro Royal Guards' Kampilan Sword	#08	24
Moro Royal Queens' Armor Full Set #2		27
Moro Royal Queens' Face Mask	#09	28
Moro Royal Queens' Necklace	#10	30
Moro Royal Queens' Body Armor	#11	32
Moro Royal Queens' Knee Guards	#12	34
Moro Royal Queens' Knife	#13	36
Moro Royal Queens' Round Shield	#14	38
Moro Royal Queens' Keris Sword	#15	40
Moro Royal Queens" Rectangle Shield	#16	42
Moro Royal Kings' Armor Full Set #3		
Moro Royal Kings' Crown	#17	46
Moro Royal Kings' Face Mask	#18	48
Moro Royal Kings' Vest	#19	50
Moro Royal Kings' Belt	#20	52
Moro Royal Kings' Groin Protector	#21	54
Moro Royal Kings' Knee Guards	#22	56
Moro Royal Kings' Keris Sword	#23	58
Moro Royal Kings' Rectangle Shield	#24	60
Moro Royal Kings' Knife	#25	62
Moro Royal Kings' Round Shield	#26	64
Little Extras of MOROLAND MUSEUM		
Funny Money (Japanese Filipino WWII Occupation money)		67
About Next Edition		70
Conclusion		71
Statements		72
Additional Rare Books		73
Toraja Indonesian Warriors' Armor Silhouette		BACK COVER

ROYAL COURT ARMOR of MOROLAND MUSEUM

INTRODUCTION

This book was created as a Historical Pictorial Publication for use by collectors and people wanting to have a reference guide for Moro Armor from the Royal Court of Moroland Museum or just as a reference guide for Filipino Armor.

Most of the Filipino Royal Moro armor in this book is from a Royal set of armor that was commissioned to be made for a very wealthy family in Manila, Philippines. It was sold back to the armory after the original owner had passed away and their family no longer wanted to retain the Royal Moro Armor in their possession. A friend of Moroland Museum purchased the set of Royal Moro Armor from the armory on one of his business trips to Manila. The rest of the Royal Moro armor is from the Mindanao region of the Philippines.

The collection of Royal Moro armor presented in this book is composed from several private collections of Moro armor that were loaned to Moroland Museum Publications Staff to create this unique documentation to share with the world. Although this collection of Royal Moro armor may not be the oldest set of Moro Armor, it is very rare to see this type of Royal Moro armor in any book, as it is rarely seen or documented for publication to the public.

Moroland Museum Historical Publications Staff is honored to publish this unique one-of-a-kind (that we know of) book for all to enjoy!

BACKGROUND

Moro Tribes Historical Background:

The armor and weapons in this book were purchased from many different sellers and from many different countries.

While the exact age of these items are hard to determine, The Moroland Museum Field Collections Specialist have met many of the original people who purchased these artifacts while they were in the military (veterans) or as tourist giving the Moroland Museum an approximate date range as to the age of the items presented in this book. These armor sets, weapons and artifacts were purchased by their original owners starting from 1940's, up to the early 1990's.

Moro People:

The meaning of the current term "Bangsamoro" is derived from the old Malay word "bangsa" and means "race" or "nation". It refers to the people in the "Moro" tribe and is now used to describe both the Filipino Muslims and their homeland. The word Moro itself was a pseudonym which had been used before in the 16th century by Spanish colonizers in reference to a Muslim group of "Moors" people from the northwest Africa area. The term was used by the Spanish when they arrived in the Philippine archipelago and found a similar Muslim community who rebelled against them.

Most of the Moro people live in Mindanao, Sulu and Palawan. Due to the continuous movement of their people since the 16th century until present, their communities can be found in all large cities in the Philippines, including Manila, Cebu and Davao. The Moros have resisted against the Spanish, American and Japanese rule for over 400 years.

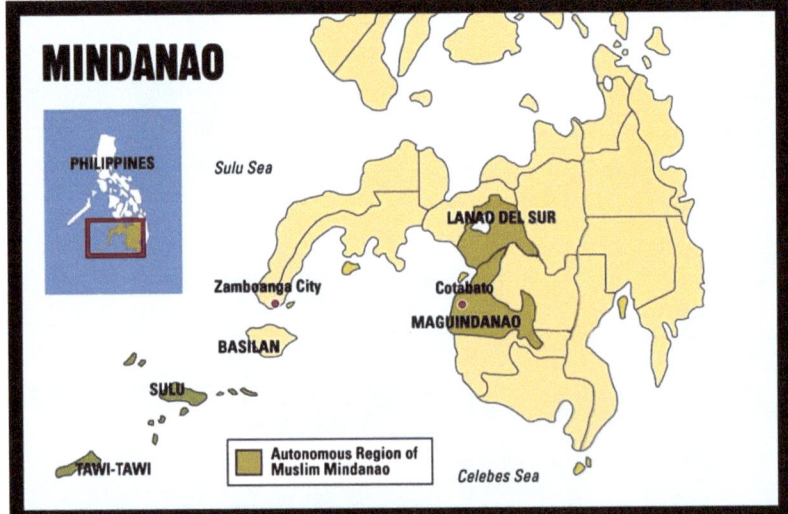

BACKGROUND

Moroland Museums' Armor Collection:

The Royal Court of Moroland Moro Armor Collection consists of three sets of Moro armor and their associated weapons. These rare Royal sets of Moro Armor consist of a Royal Moro Guard, the Royal Moro Queen, the Royal Moro King.

Hard to find:

The Royal Moro Armor pieces in this book are getting hard to find. They are even harder to find in good condition. It's difficult to tell exactly when these armor pieces were crafted. We can assume they were crafted between the 1900's to the late 1970's. This type of armor takes proper maintenance and care to preserve it from being damaged due to rust caused by the humid climate they reside in.

Craftsmanship and Quality:

All of these pieces of Royal Moro Armor show unique level of craftsmanship. When you inspect the different pieces of this armor, the detail put into each individual piece is obvious as they are masterpieces on which the craftmen show off their talents.

ROYAL COURT ARMOR of MOROLAND MUSEUM

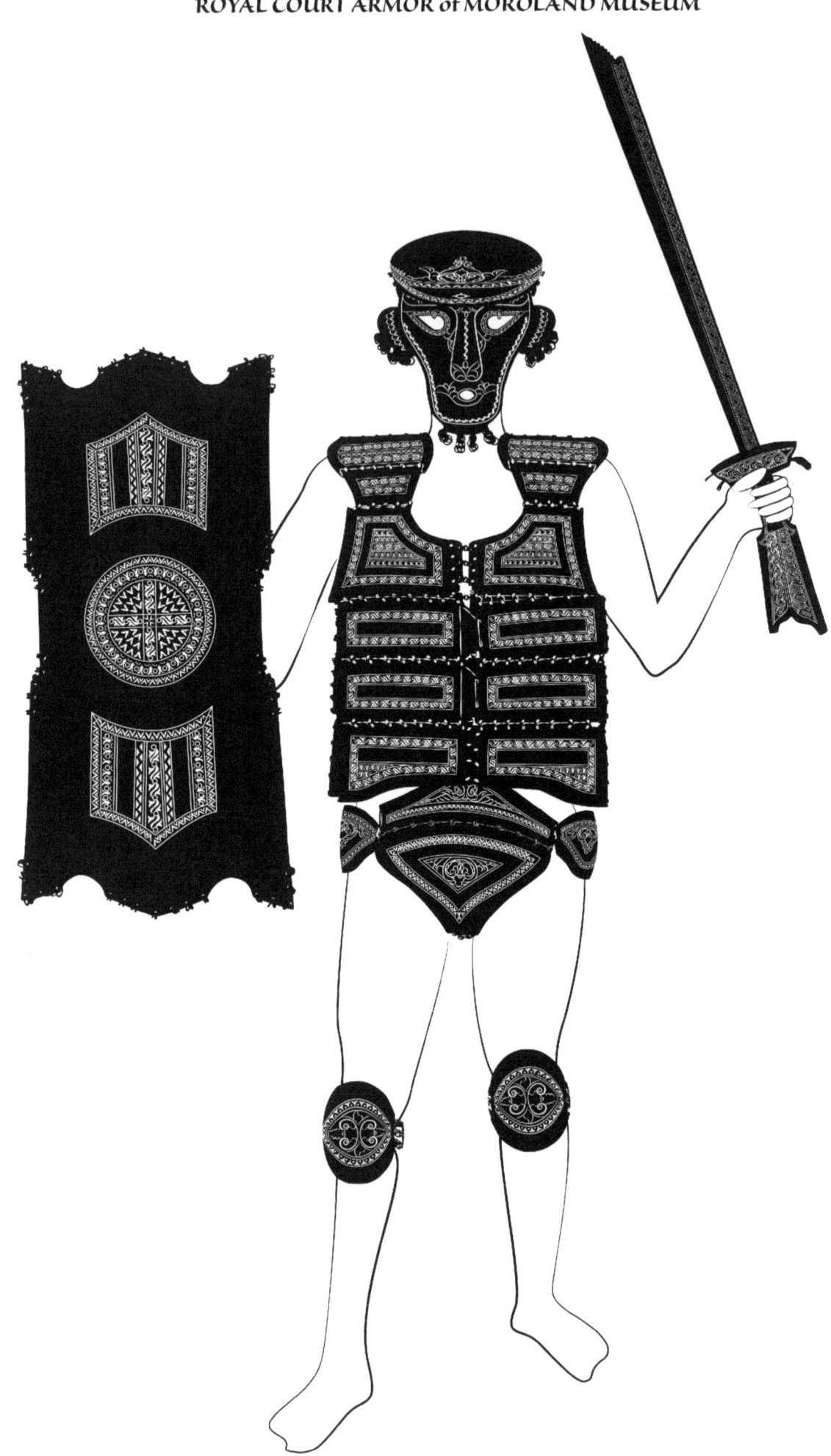

ROYAL COURT ARMOR of MOROLAND MUSEUM

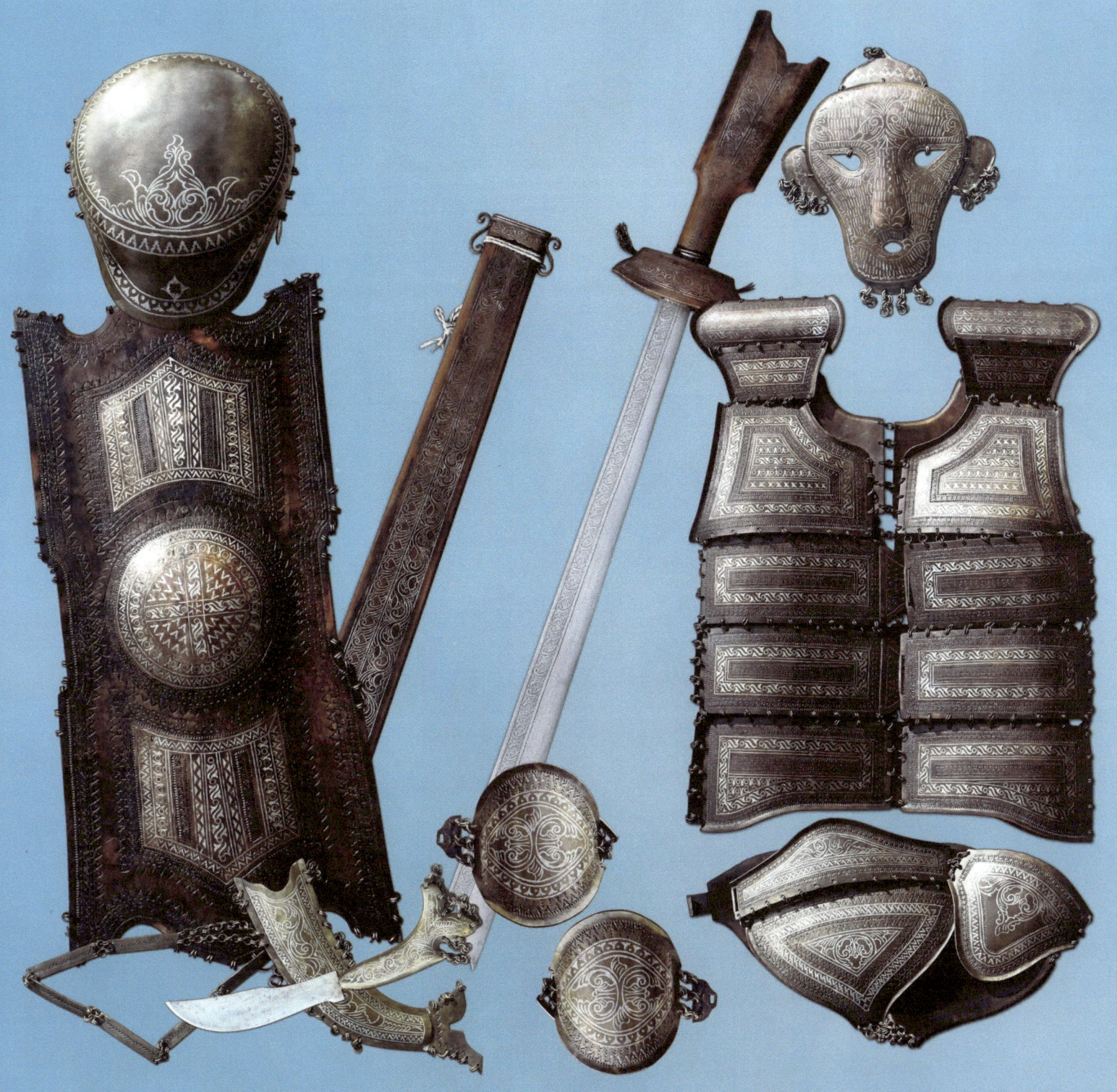

The Royal Moro Guards set of Armor: (Set # 1):

The first set of armor in the Royal Court is the Royal Moro Guards' set. This full Royal Combat set consists of a Helmet, Mask, Vest, Groin protector, Knee Guards, Dagger, Rectangular Shield and a Kampilan Sword. Each piece in this Royal Guard set is made of bronze with an ornate silver inlay design. These were crafted for display purposes to show wealth and power, instead of use in actual combat. Although this set of armor isn't one of the oldest sets, it is very rare to have this full suit of armor.

ROYAL COURT ARMOR of MOROLAND MUSEUM

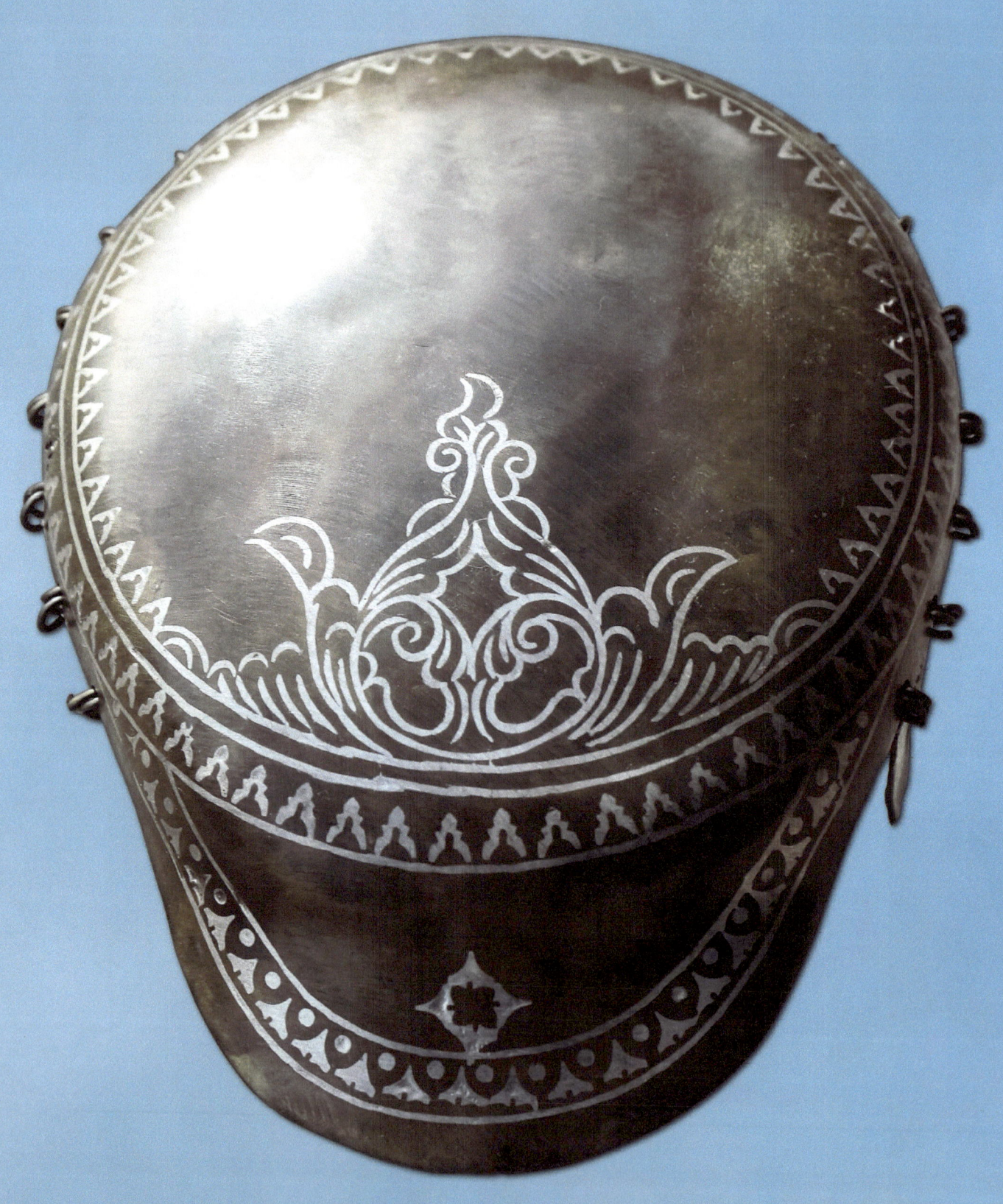

Royal Moro Guards' Helmet #01

ROYAL COURT ARMOR of MOROLAND MUSEUM

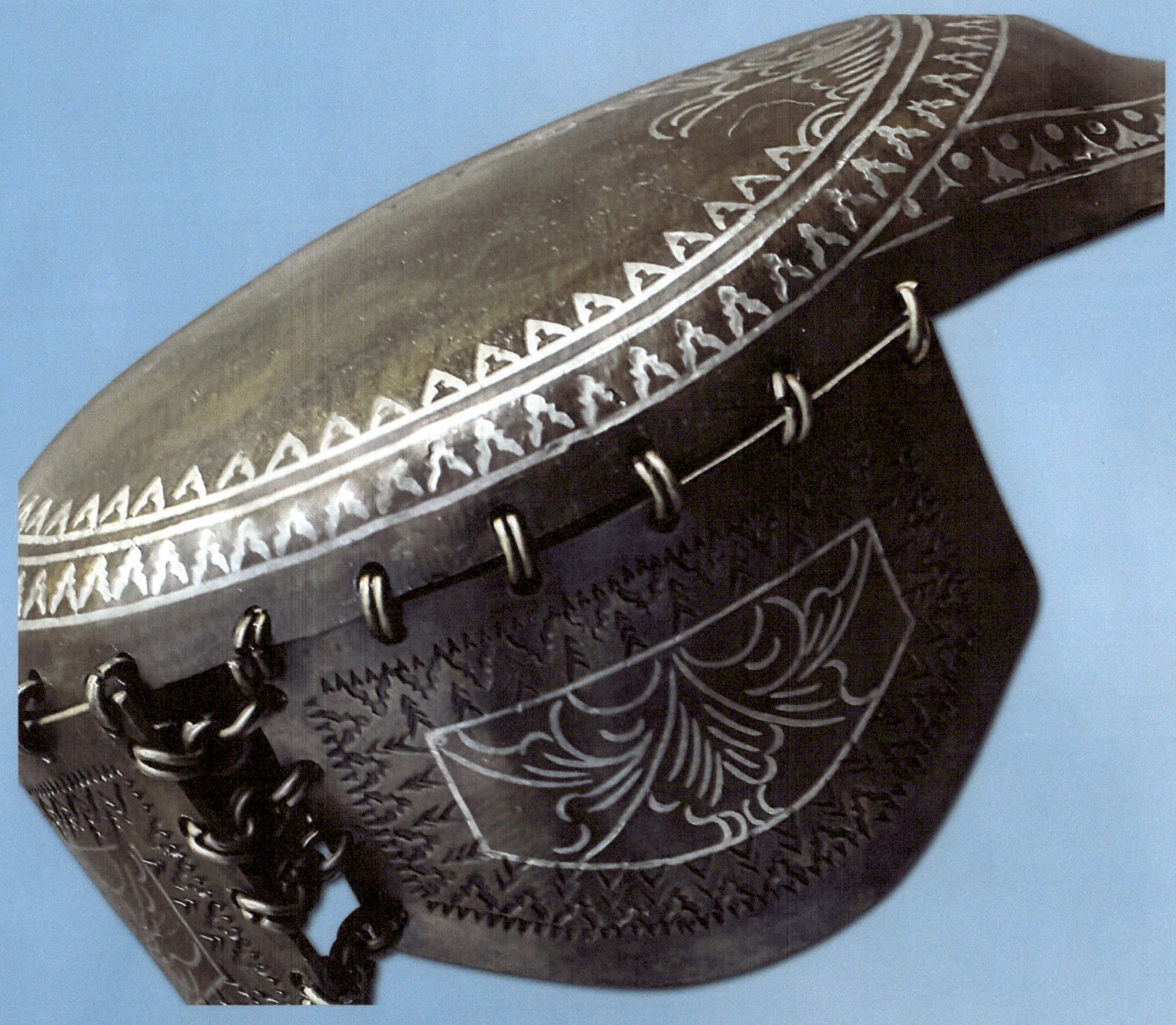

Royal Moro Guards' Helmet #01

Description: This royal guards' combat helmet is made of bronze with an ornate pattern stamp engraved with silver ethnographic (Okir) designs. It has chain mail rings that link the head and ear protectors.

Length: 12 ins Approximate Age: 1900's
Width: 8.5 ins Condition: Museum Quality

Location Purchased: Ebay
Location Found: Lake Lanao, Mindanao, Philippines

ROYAL COURT ARMOR of MOROLAND MUSEUM

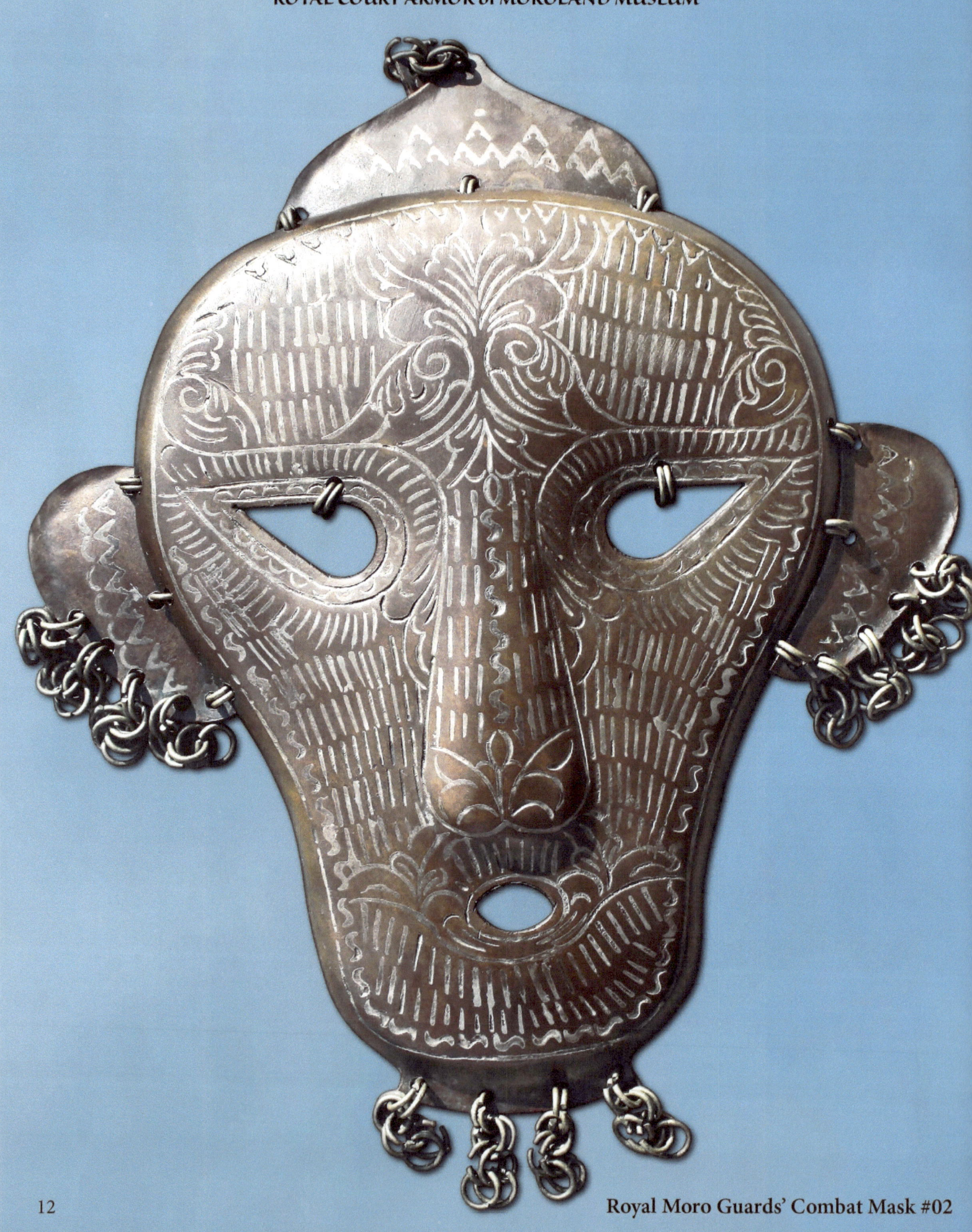

Royal Moro Guards' Combat Mask #02

ROYAL COURT ARMOR of MOROLAND MUSEUM

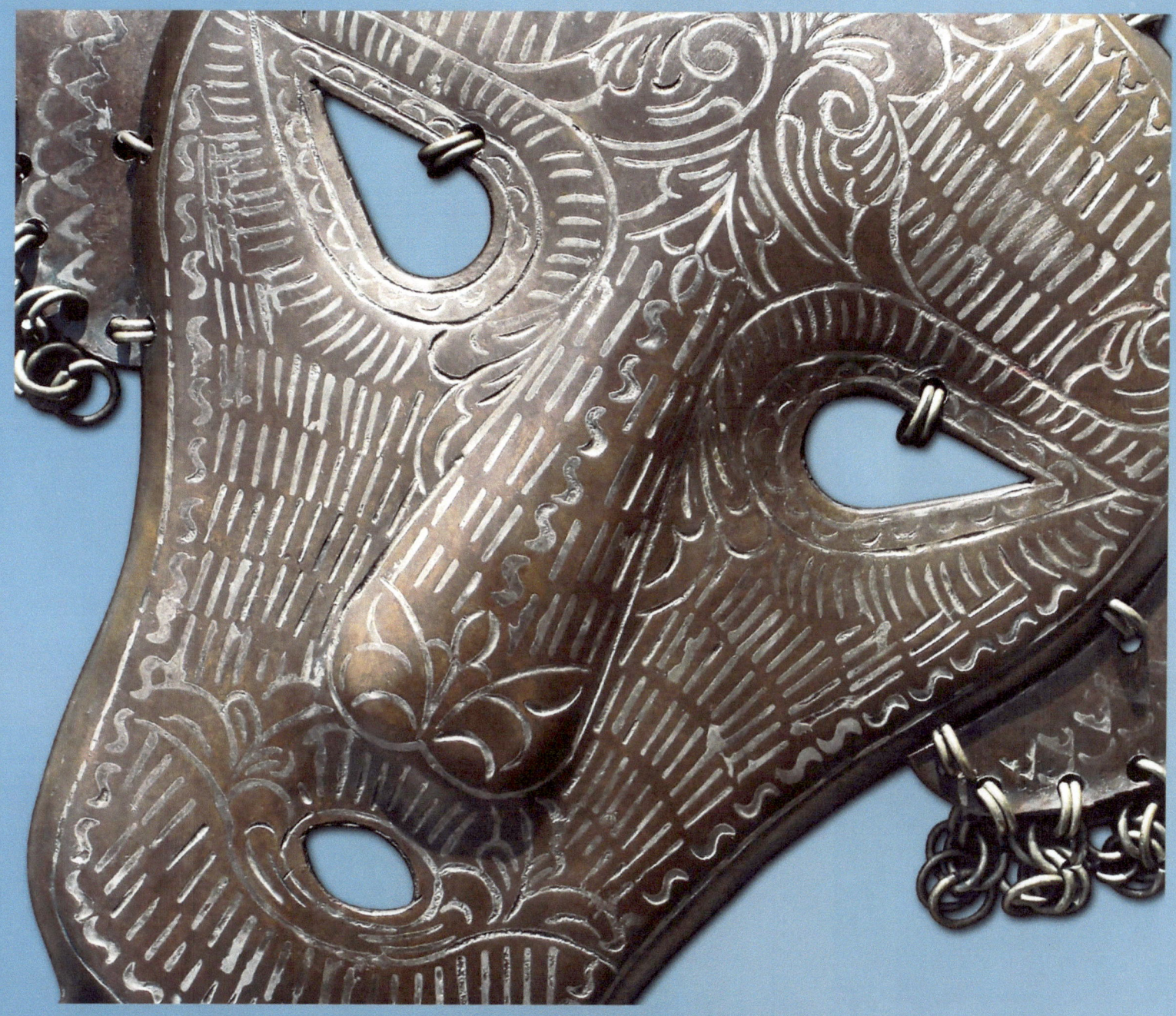

Royal Moro Guards' Combat Mask #02

Description: This royal guards' face mask is made of bronze with an ornate pattern inlaid in silver. The head and ear protectors are connected with chain links, while short chain links hang off the ears and chin.

Length: 9 ins Approximate Age: 1900's
Width: 7 ins Condition: Museum Quality

Location Purchased: Ebay
Location Found: Lake Lanao, Mindanao, Philippines

ROYAL COURT ARMOR of MOROLAND MUSEUM

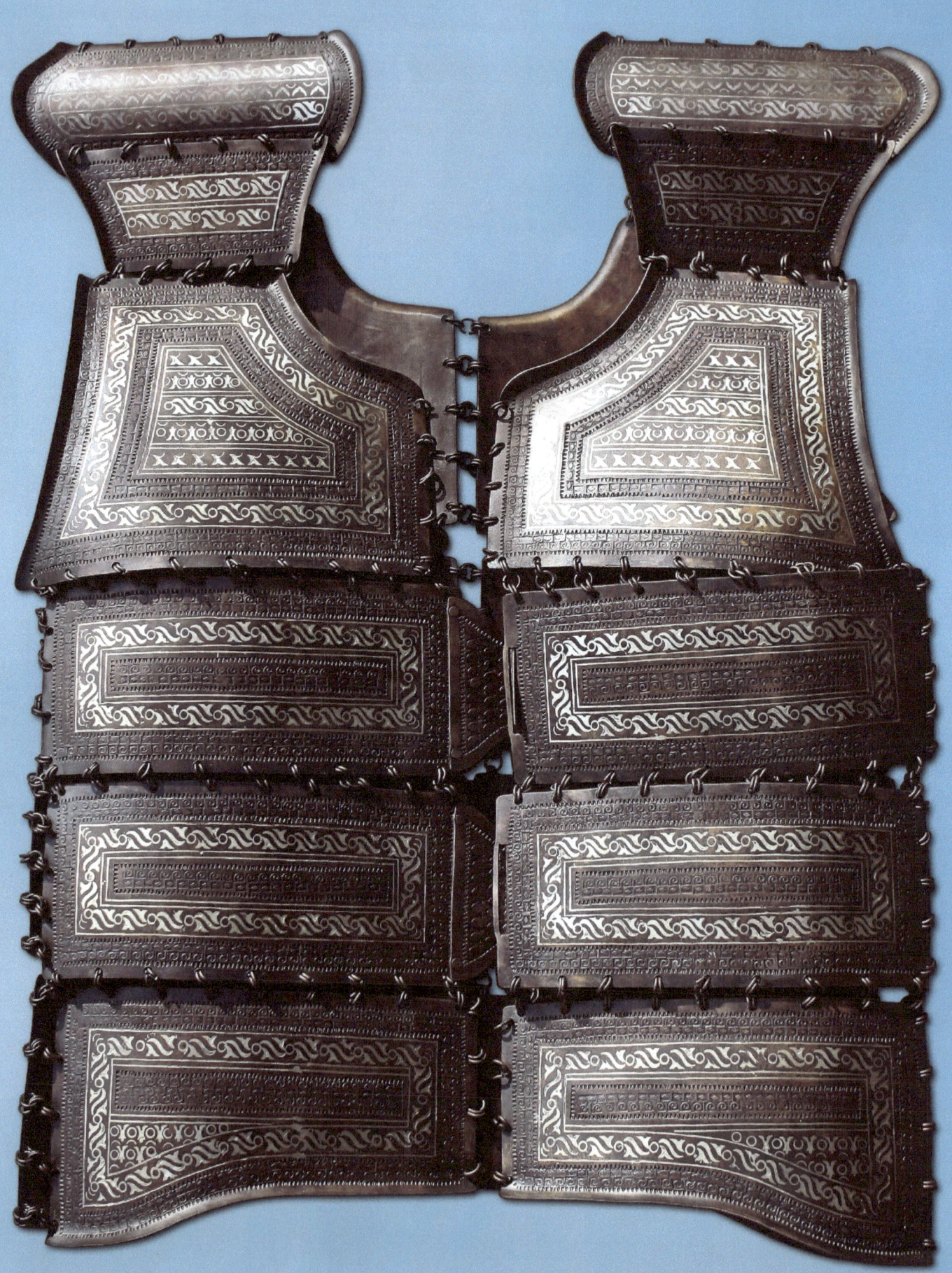

Royal Moro Guards' Combat Vest #03

ROYAL COURT ARMOR of MOROLAND MUSEUM

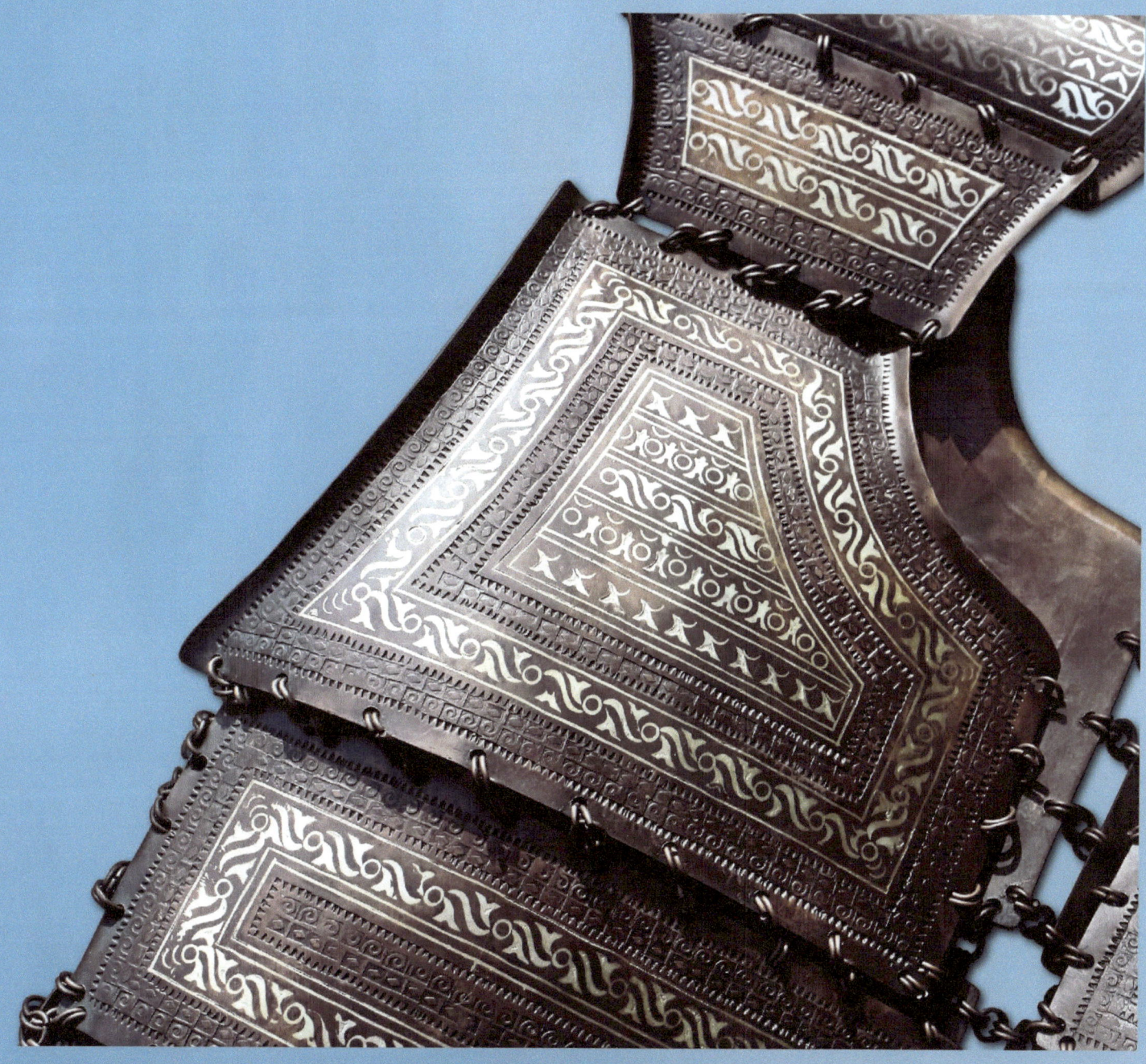

Royal Moro Guards' Combat Vest #03

Description: This royal guards' combat vest is made out of bronze with an ornate pattern inlaid in silver. This vest is a little heavy in weight since each metal plate is attached by chain links.

Length: 22 ins Approximate Age: 1900's
Width: 15 ins Condition: Museum Quality

Location Purchased: Ebay
Location Found: Lake Lanao, Mindanao, Philippines

ROYAL COURT ARMOR of MOROLAND MUSEUM

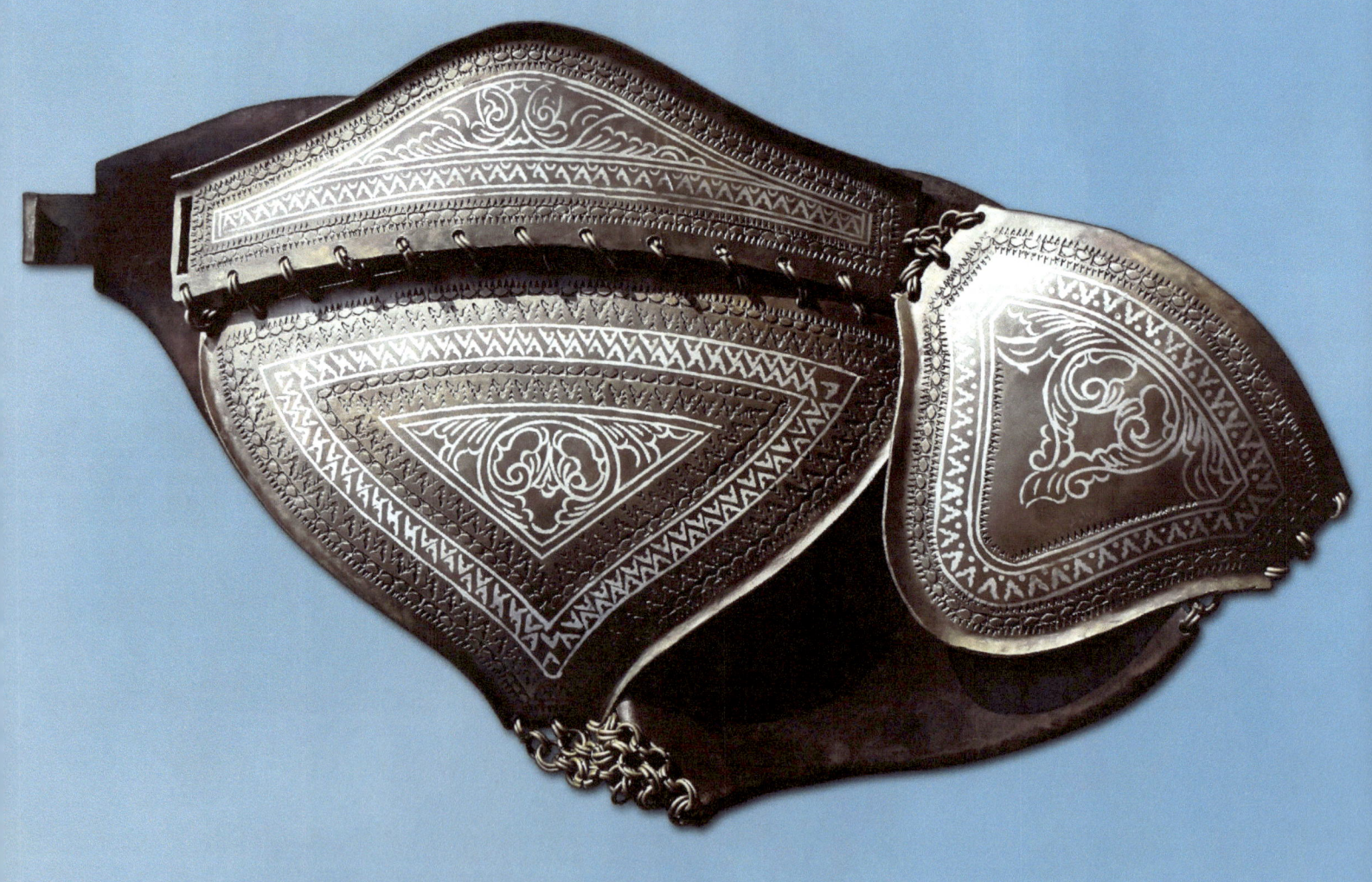

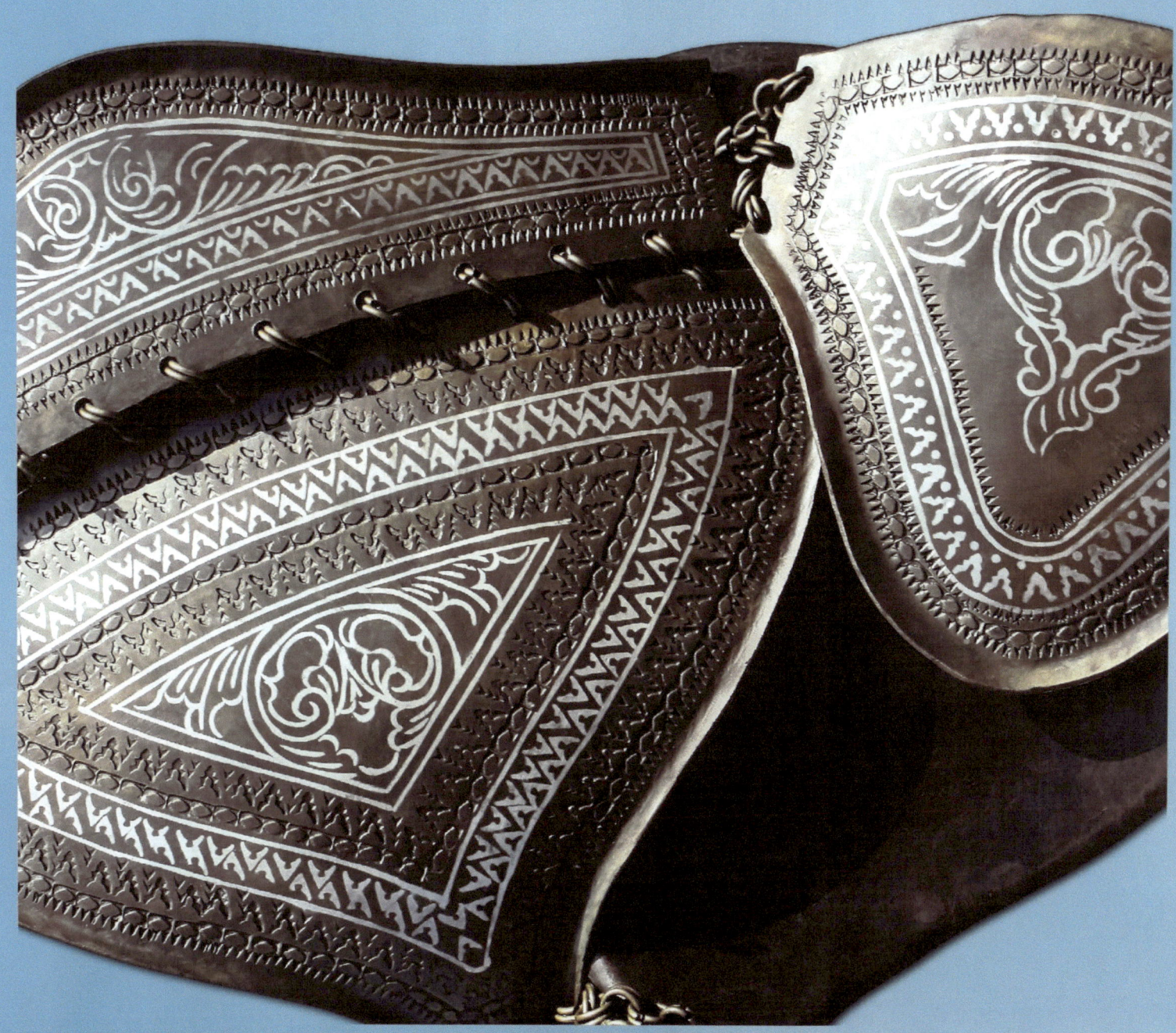

Royal Moro Guards' Groin Protector #04

Description: This royal guards' groin protector is made of bronze with an ornate pattern inlaid in silver. The metal plates are connected entirely by chain links.

Main Panels		Side Panels			
Length:	14 ins	Length:	14 ins	Approximate Age:	1900's
Width:	16 ins	Width:	16 ins	Condition:	Museum Quality

Location Purchased: Ebay
Location Found: Lake Lanao, Mindanao, Philippines

ROYAL COURT ARMOR of MOROLAND MUSEUM

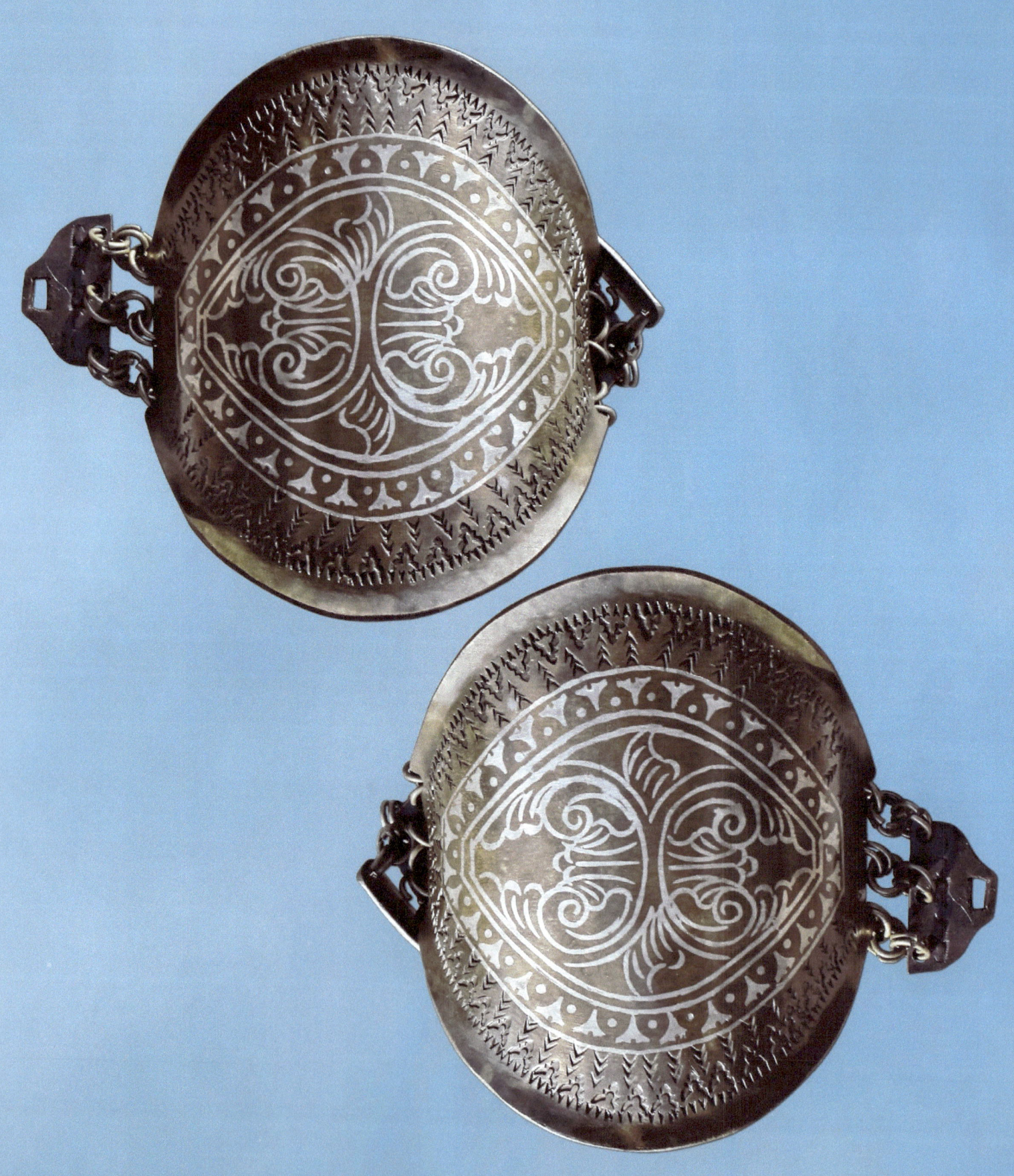

Royal Moro Guards' Knee Guards #05

ROYAL COURT ARMOR of MOROLAND MUSEUM

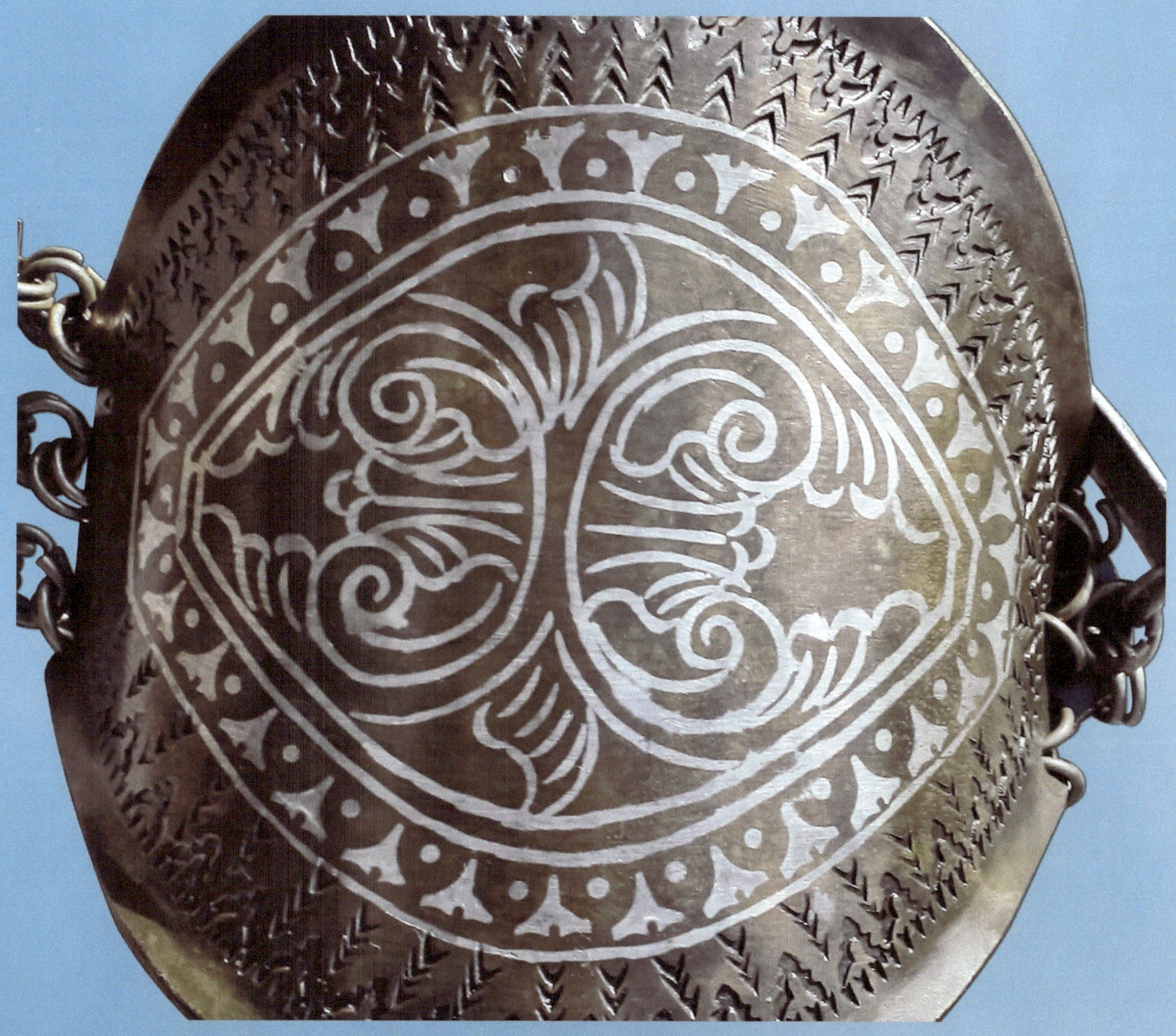

Royal Moro Guards' Knee Guards #05

Description: This royal guards' knee guards are made of bronze with an ornate pattern inlaid in silver. Each knee plate is connected by chain links.

Length: 5 ins Approximate Age: 1900's
Width: 5 ins Condition: Museum Quality

Location Purchased: Ebay
Location Found: Lake Lanao, Mindanao, Philippines

ROYAL COURT ARMOR of MOROLAND MUSEUM

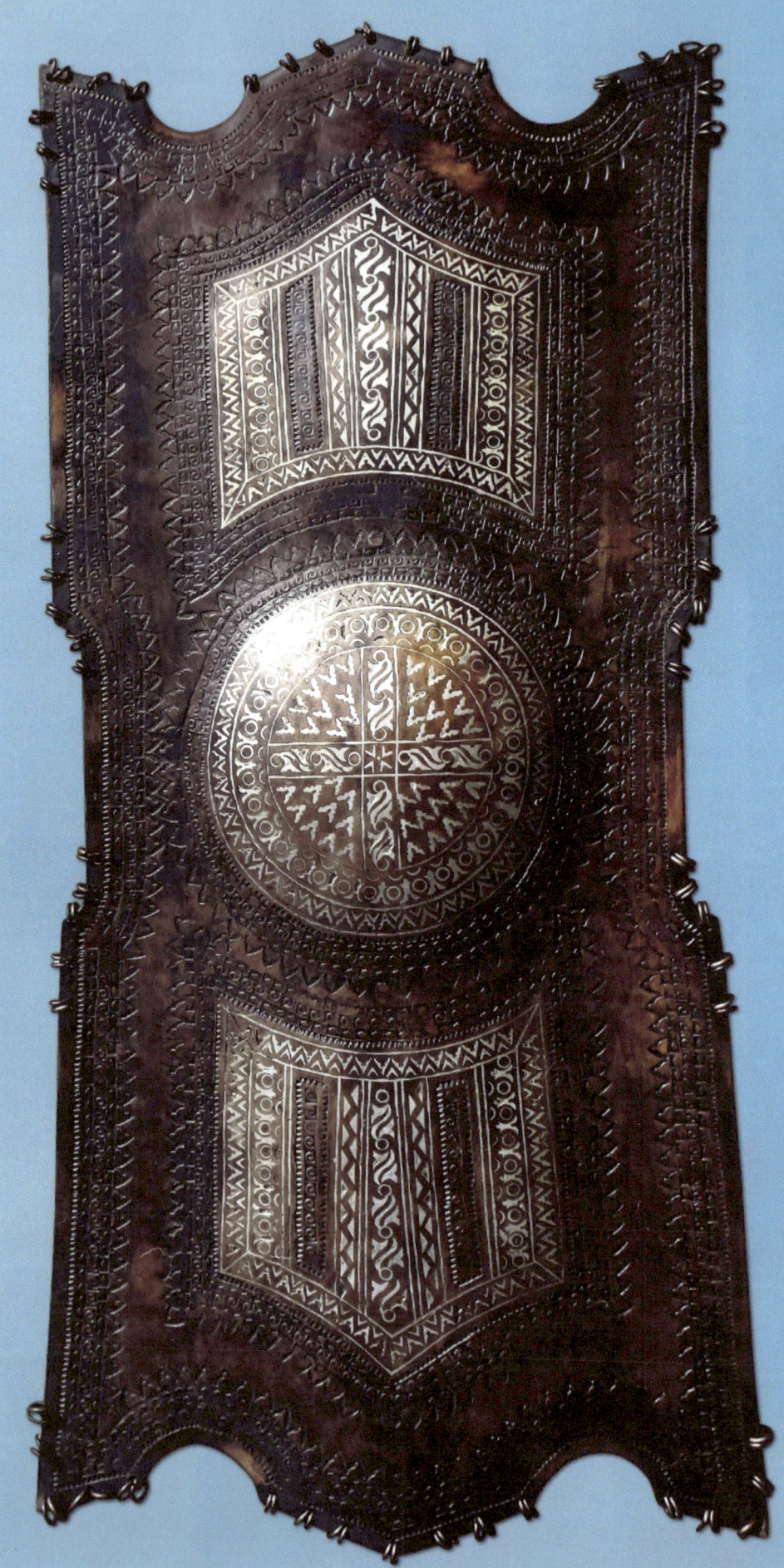

Royal Moro Guards' Rectangular Shield #06

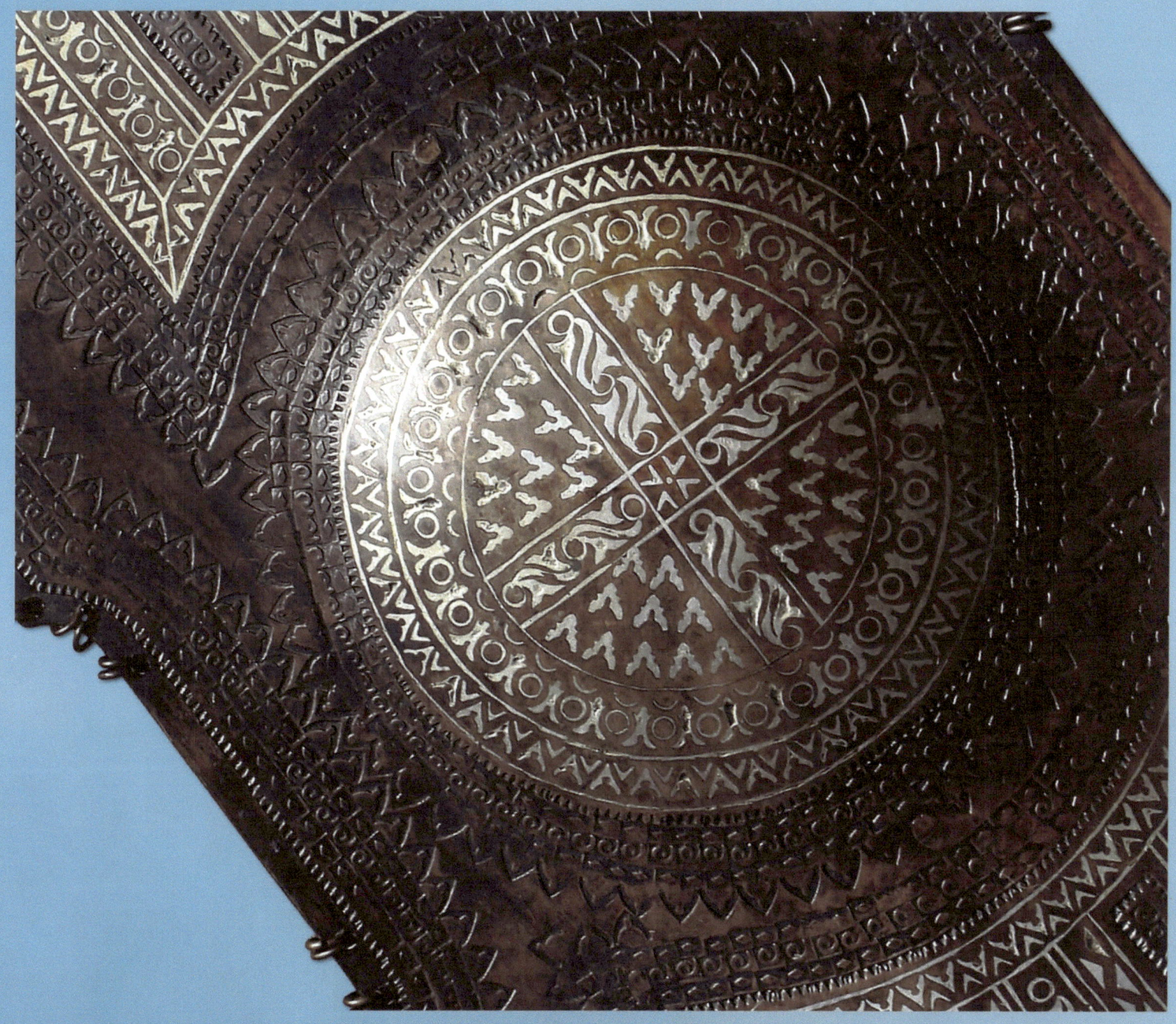

Royal Moro Guards' Rectangular Shield #06

Description: This type of royal guards' shield was used for land warfare. These rectangular style shields are made of bronze with ornate silver inlay patterns and has pierced metal surface with chain links attached. The inlay design shown is customary of the Muslim influence that is present in most of the Moro weapons and artifacts.

Length:	25 ins	Approximate Age:	1900's
Small - Large Widths:	10-12 ins	Condition:	Museum Quality

Location Purchased: Ebay
Location Found: Lake Lanao, Mindanao, Philippines

ROYAL COURT ARMOR of MOROLAND MUSEUM

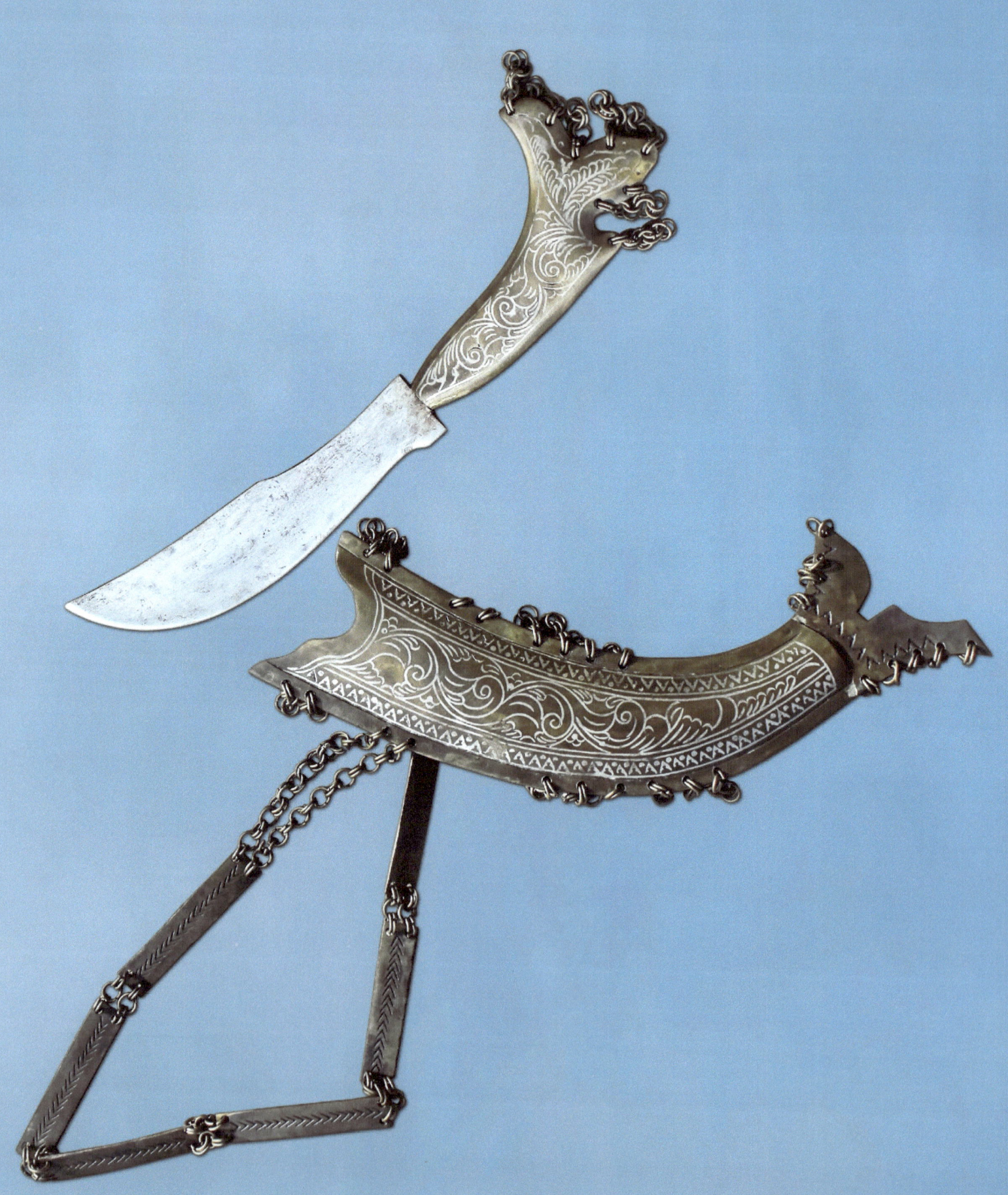

22 Royal Moro Guards' Dagger #07

ROYAL COURT ARMOR of MOROLAND MUSEUM

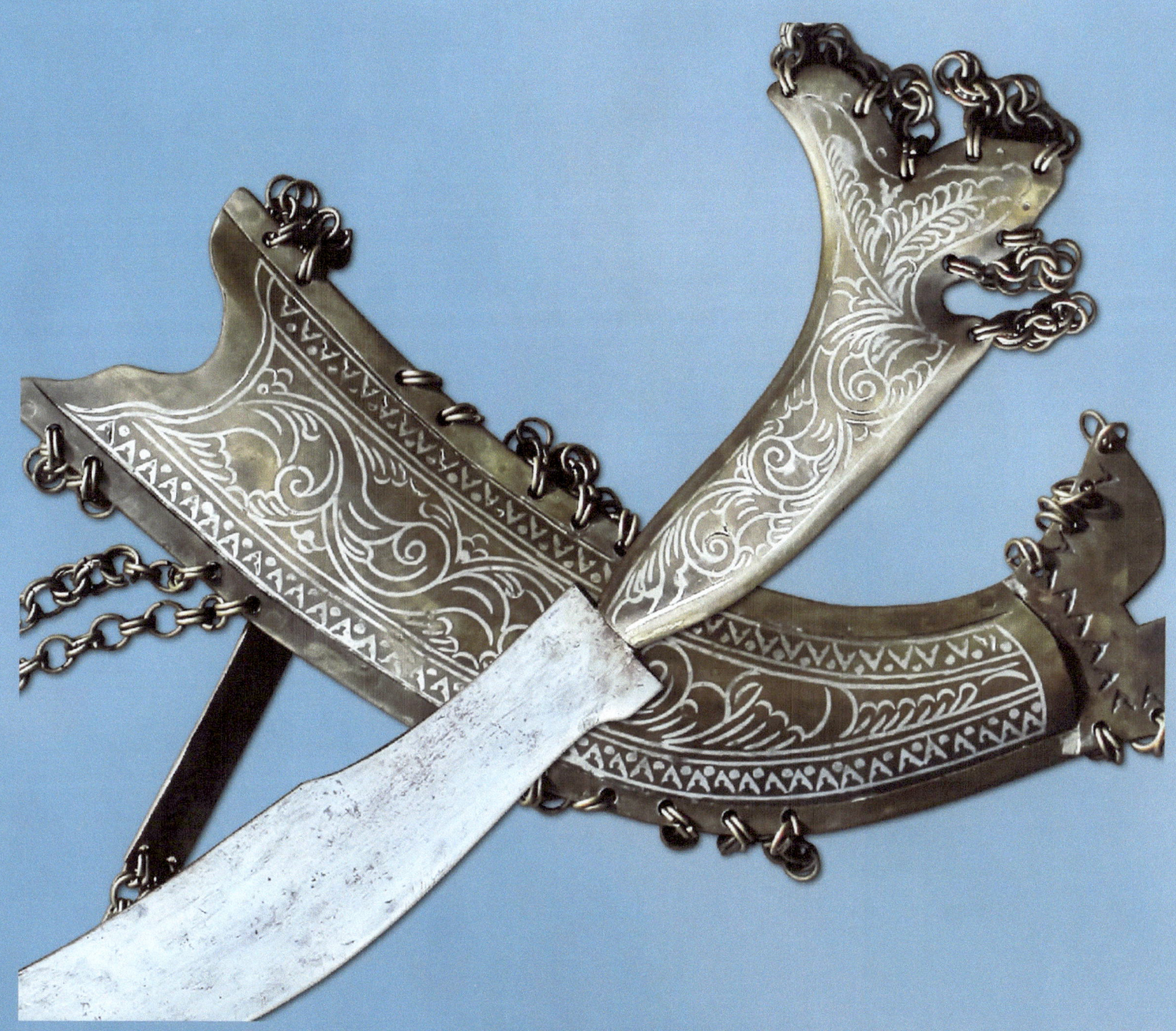

Royal Moro Guards' Dagger #07

Description: This royal guards' knife is made of bronze with an ornate silver inlay pattern. The belt is connected by pierced metal plates attached by chain links and has links lining the edges for decoration. The design on the dagger and scabbard is of the type that is customary of the Muslim influence that is present on most of the Moro weapons and artifacts found in this area.

Total Length: 14 ins Blade: 9 ins Approximate Age: 1900's
Total Widths: 5-3.5 ins Condition: Museum Quality

Location Purchased: Ebay
Location Found: Lake Lanao, Mindanao, Philippines

ROYAL COURT ARMOR of MOROLAND MUSEUM

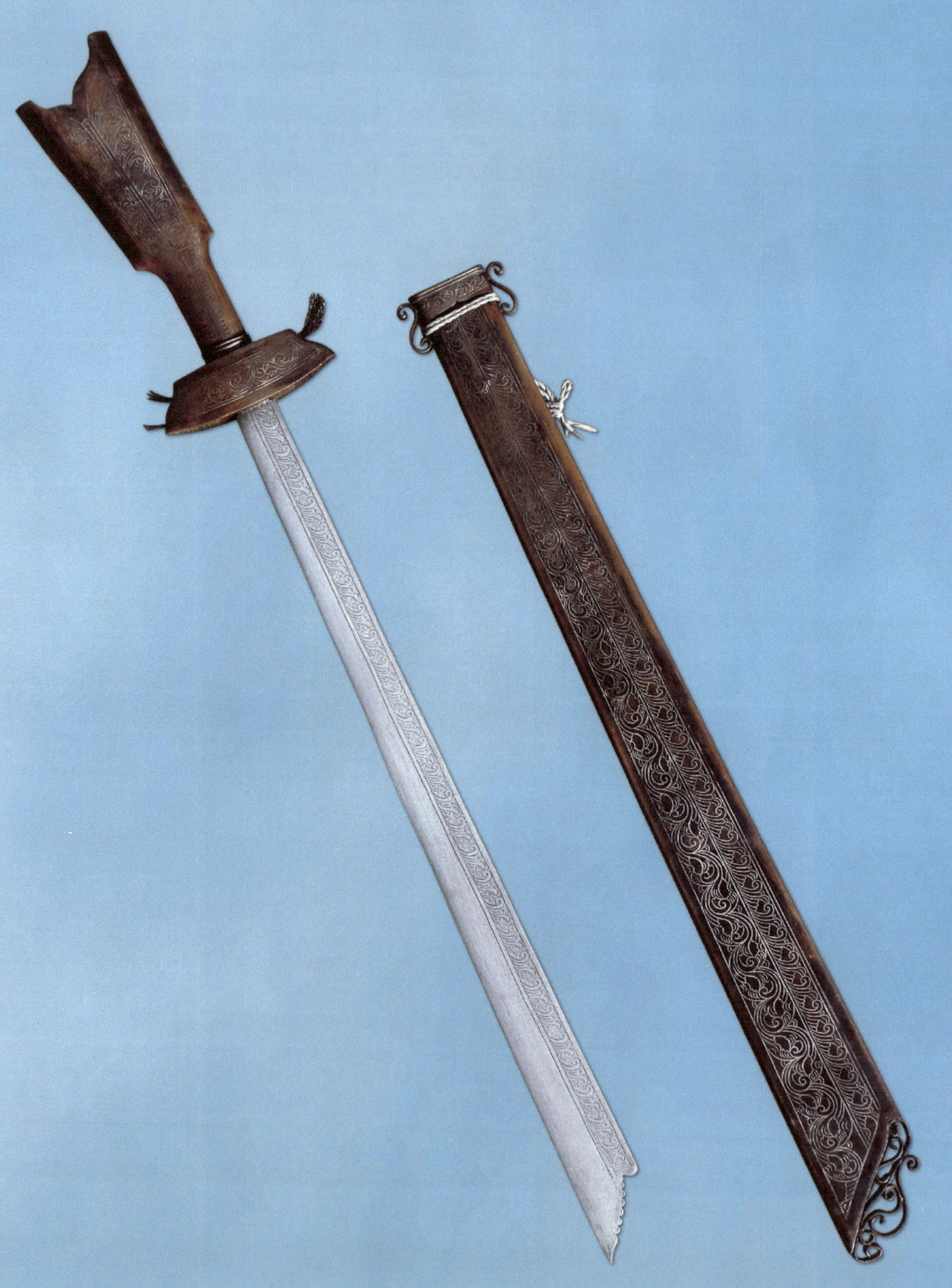

Royal Moro Guards' Kampilan Sword #08

ROYAL COURT ARMOR of MOROLAND MUSEUM

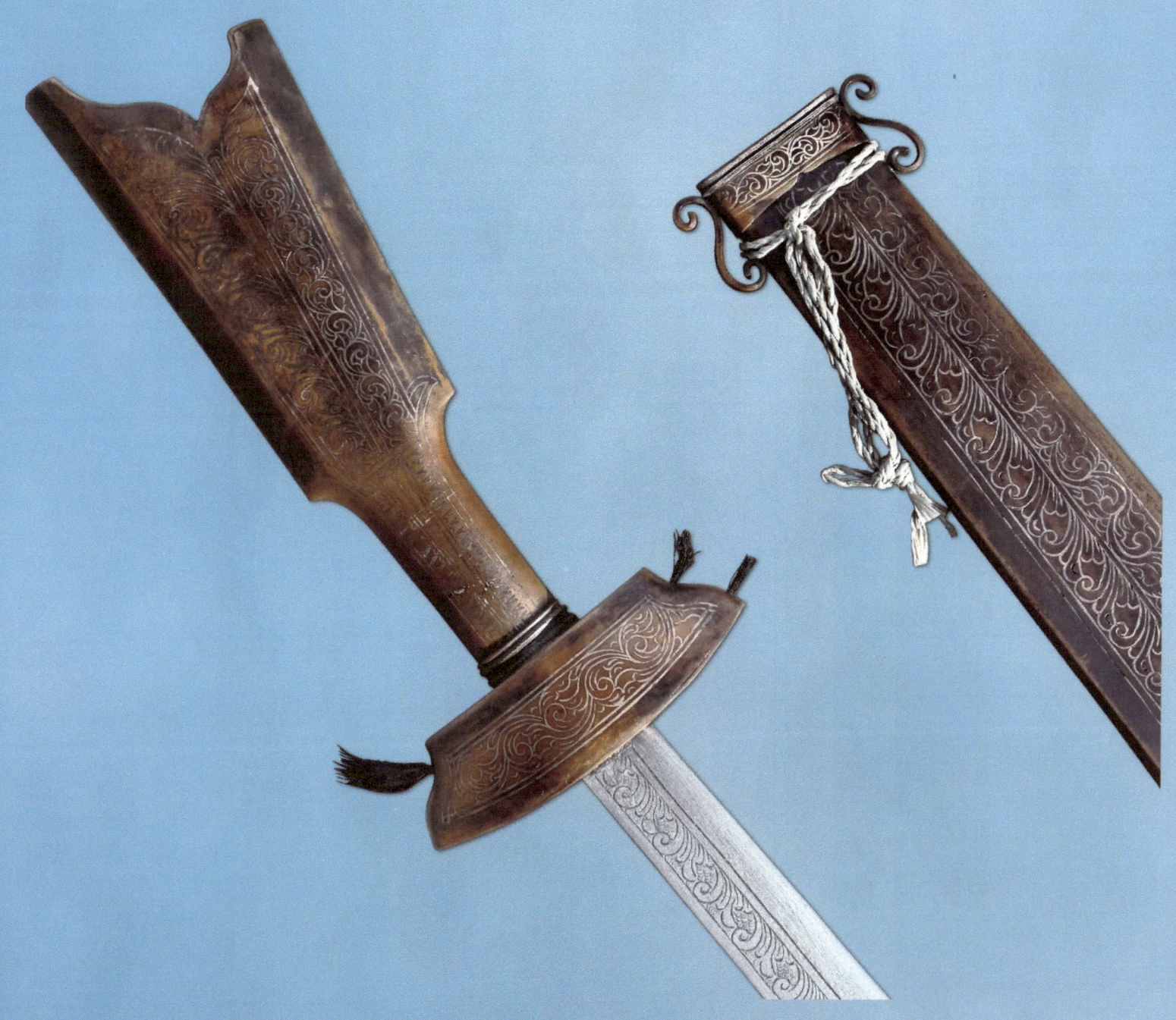

Royal Moro Guards' Kampilan Sword #08

Description: This royal guards' sword is made of steel and bronze with ornate silver inlay pattern. The handle has horse hair around the edges and an ornate scrolling opposite of its deadly sharp edge. Sword and Scabbard share the same ornate inlaid design that show the customary Muslim influences present in most of the Moro weapons and artifacts found in this region of the Philippines.

Total Length: 40 ins Blade: 29 ins Approximate Age: 1900's
Total Widths: 3.5-4 ins Condition: Museum Quality

Location Purchased: Ebay
Location Found: Lake Lanao, Mindanao, Philippines

ROYAL COURT ARMOR of MOROLAND MUSEUM

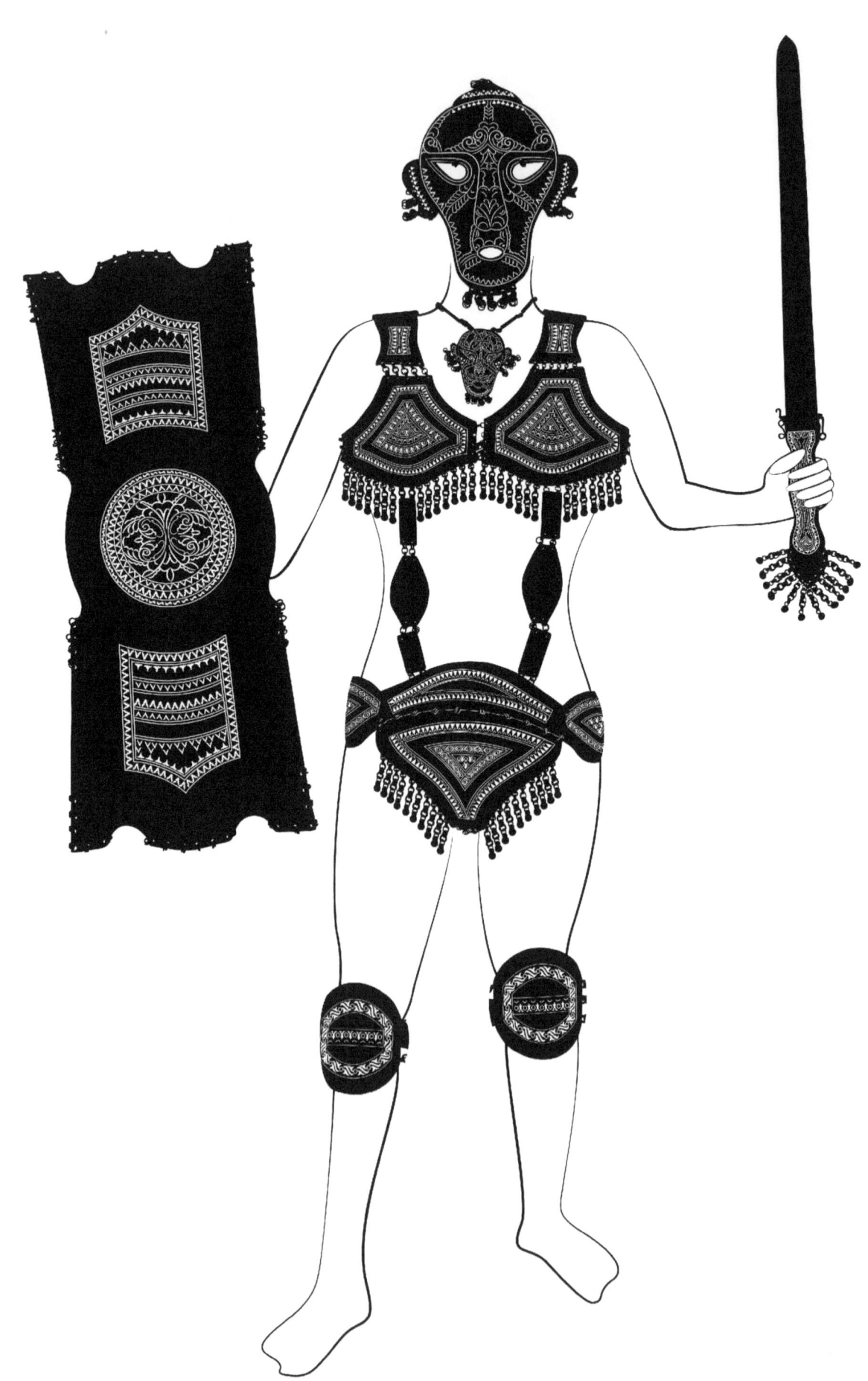

ROYAL COURT ARMOR of MOROLAND MUSEUM

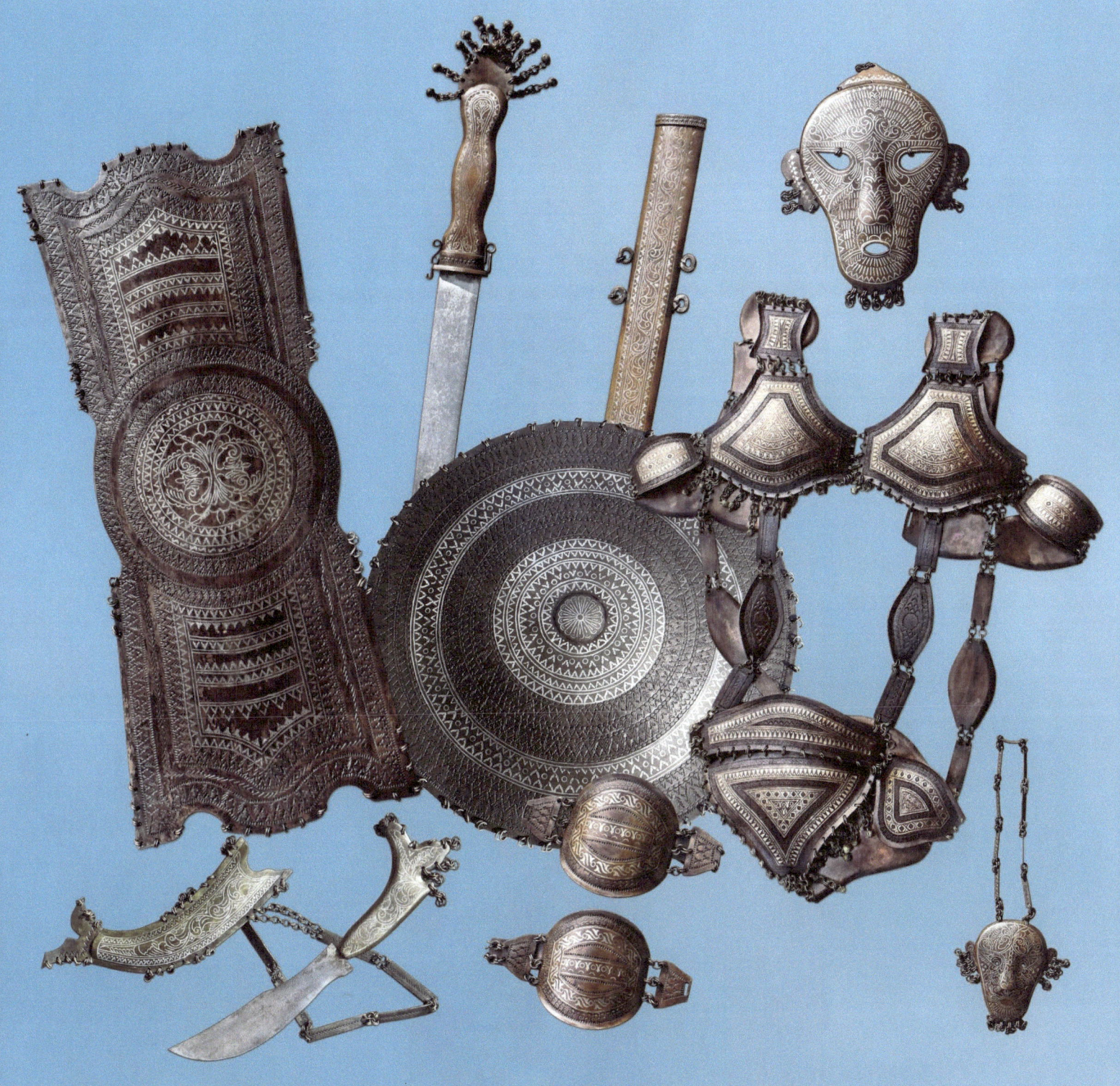

The Royal Moro Queen's set of Armor: (Set # 2):

 The second set of armor in the Royal Court is the Queen's Set. This Royal Combat Set consists of a Mask, Necklace, Breast and Groin Protector, Knee Guards, Dagger, Round Shield, Rectangular Shield and a Sword. Each piece in this Royal set of armor is made of bronze with an ornate silver inlay design. These were crafted for display purposes to show wealth and power, instead of use in actual combat. Although this set of armor isn't one of the oldest sets, it is very rare to have this full suit of armor.

ROYAL COURT ARMOR of MOROLAND MUSEUM

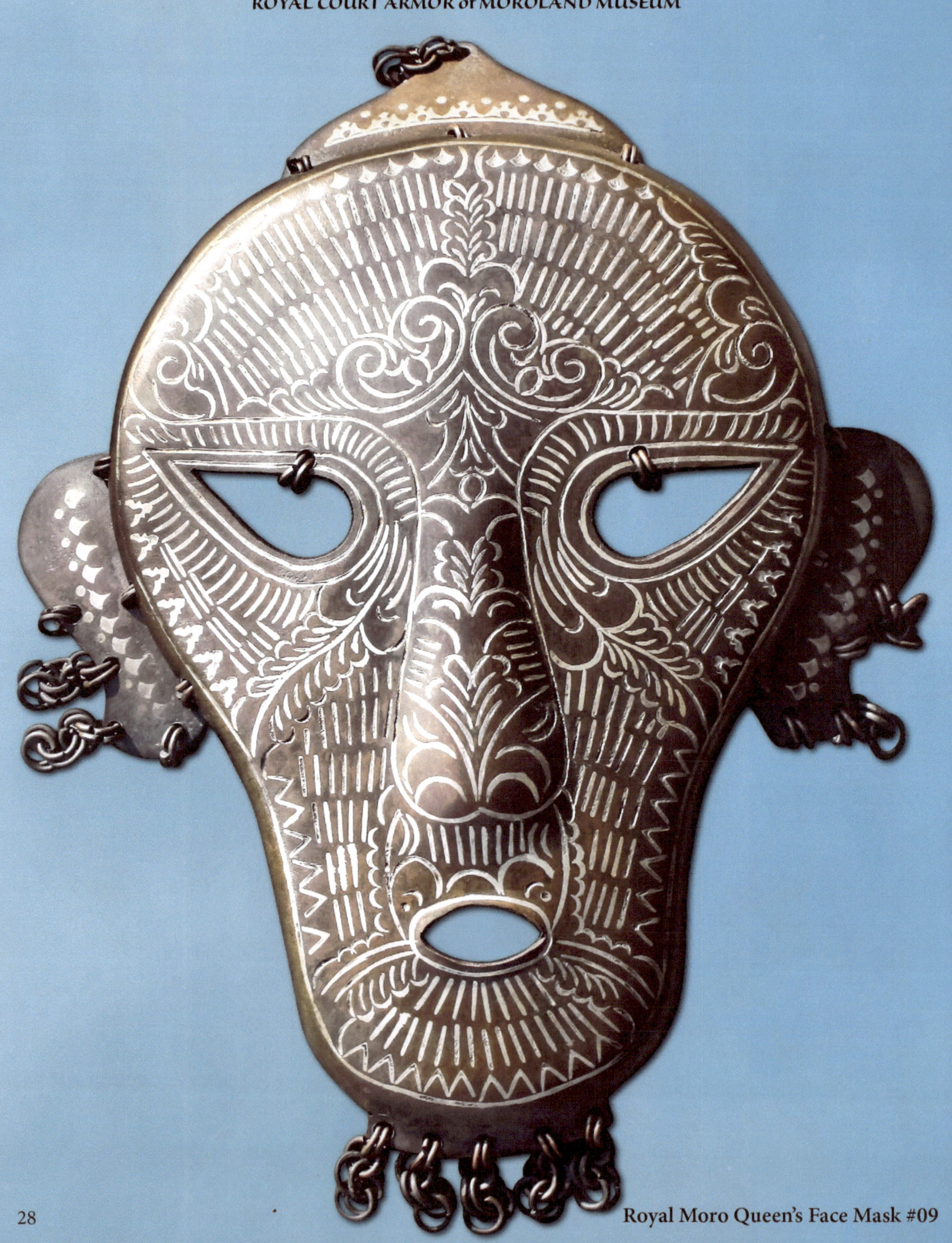

Royal Moro Queen's Face Mask #09

ROYAL COURT ARMOR of MOROLAND MUSEUM

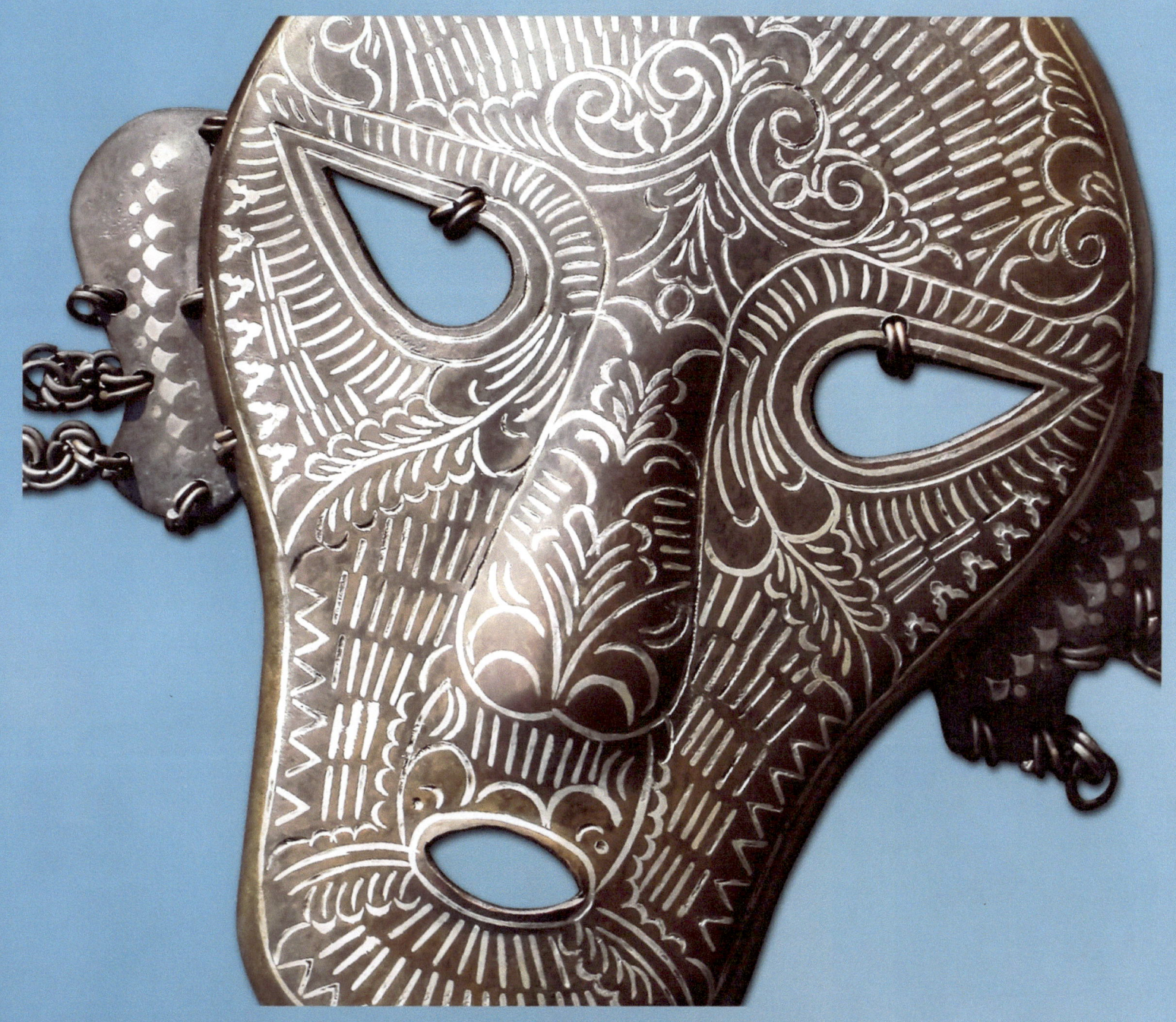

Royal Moro Queen's Face Mask #09

Description: This royal queen's face mask is made of bronze with an ornate pattern inlaid in silver. The head and ear protectors are connected with chain links, while short chain links hang off the ears and chin.

Total Length: 9 ins Approximate Age: 1900's
Total Widths: 7 ins Condition: Museum Quality

Location Purchased: Ebay
Location Found: Lake Lanao, Mindanao, Philippines

ROYAL COURT ARMOR of MOROLAND MUSEUM

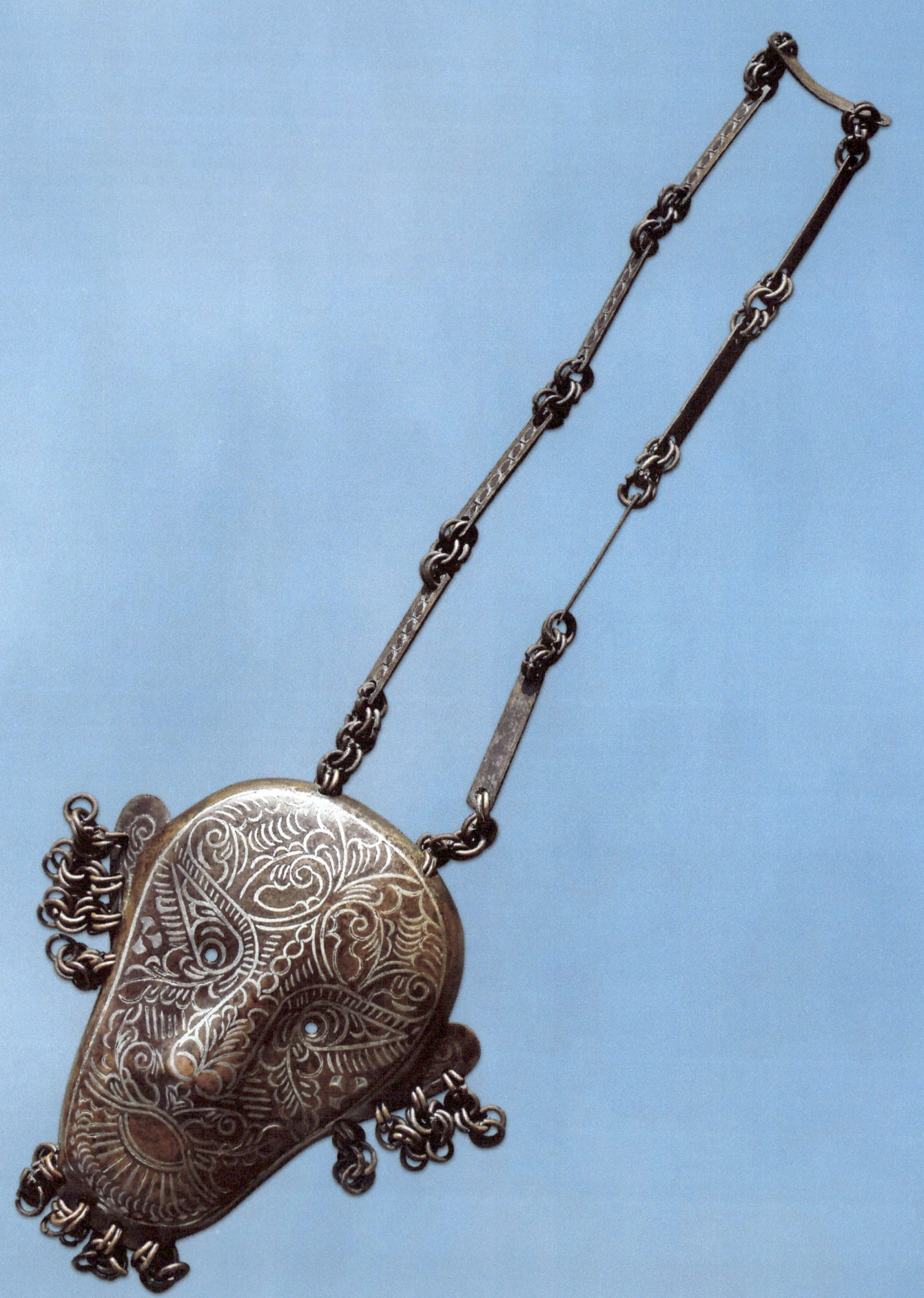

Royal Moro Queen's Necklace #10

ROYAL COURT ARMOR of MOROLAND MUSEUM

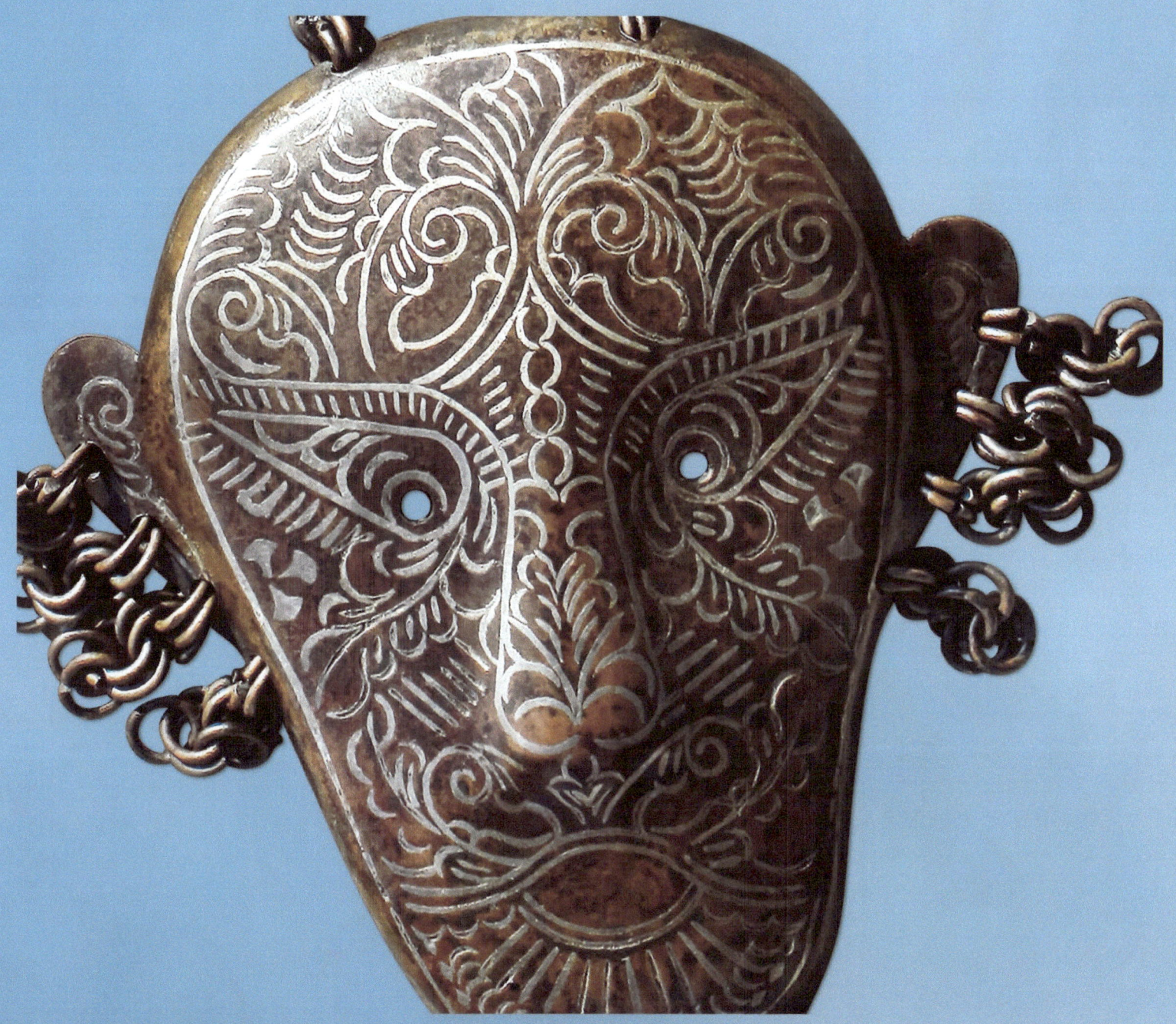

Royal Moro Queen's Necklace #10

Description: This royal queen's combat necklace is made of bronze with an ornate silver inlay design. The ear guards and chin are lined with chain links.

Total Length: 5 ins
Total Widths: 4 ins
Approximate Age: 1900's
Condition: Museum Quality

Location Purchased: Ebay
Location Found: Lake Lanao, Mindanao, Philippines

ROYAL COURT ARMOR of MOROLAND MUSEUM

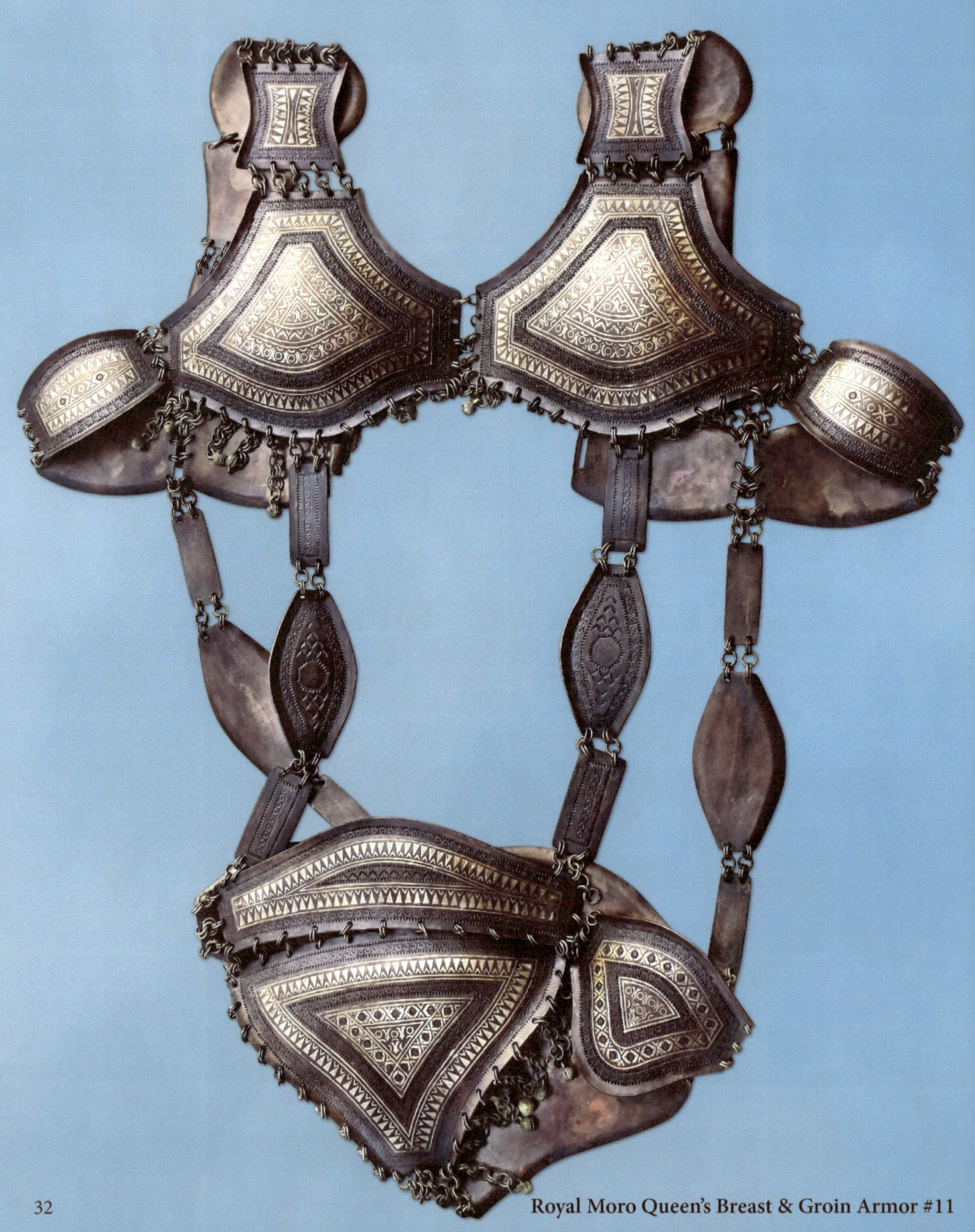

Royal Moro Queen's Breast & Groin Armor #11

ROYAL COURT ARMOR of MOROLAND MUSEUM

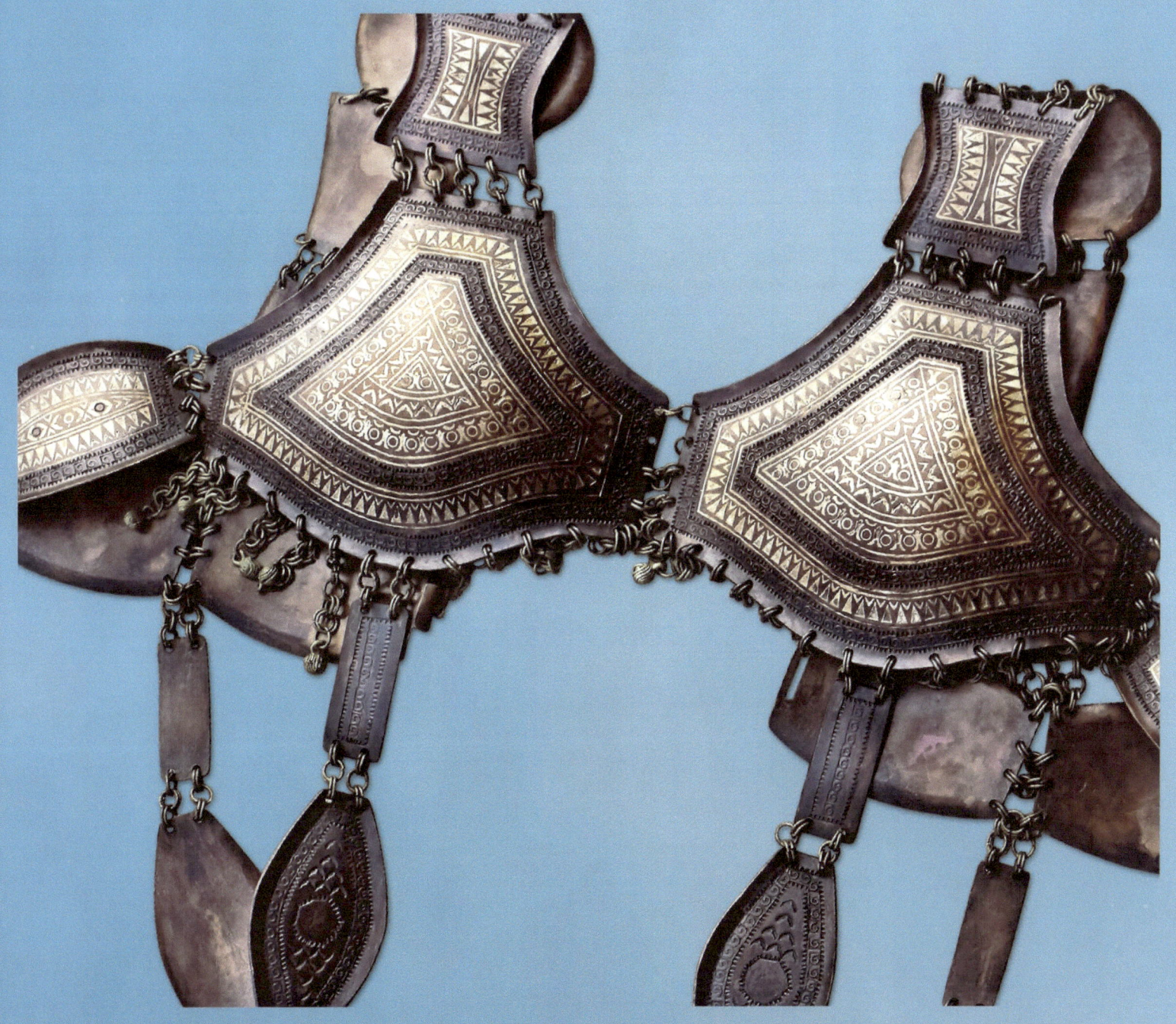

Royal Moro Queen's Breast & Groin Armor #11

Description: This royal queen's combat armor is made of bronze with an ornate silver inlay design. Chain links attach the shoulder, breast and groin protector plates together. Chain links also line the breast and groin protector for decoration.

Breast Guard	Groin Guard	Metal Connectors		
Length: 14 ins	Length: 14 ins	Length: 8 ins	Approximate Age:	1900's
Widths: 15 ins	Widths: 16 ins		Condition:	Museum Quality

Location Purchased: Ebay
Location Found: Lake Lanao, Mindanao, Philippines

ROYAL COURT ARMOR of MOROLAND MUSEUM

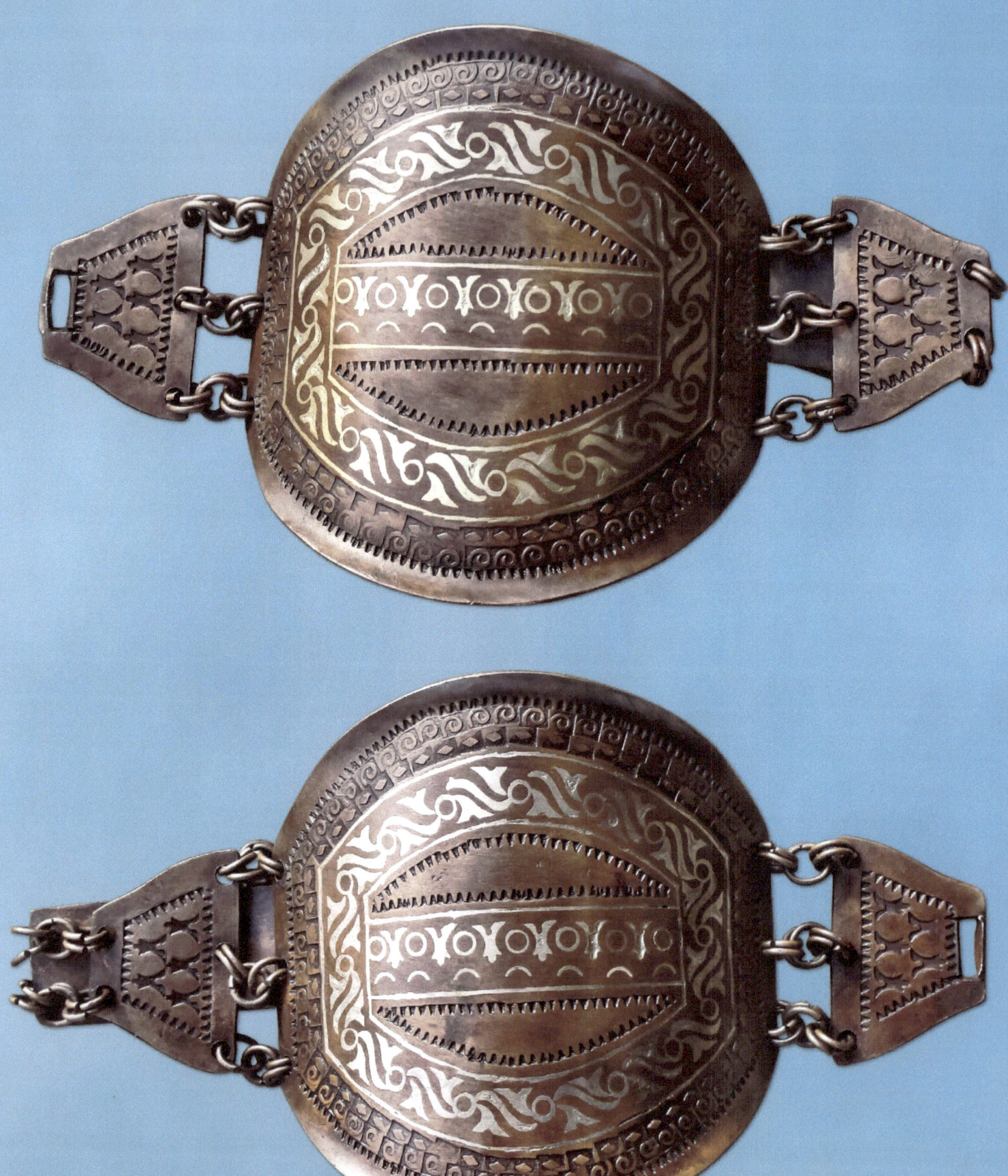

34

Royal Moro Queen's Knee Guards #12

ROYAL COURT ARMOR of MOROLAND MUSEUM

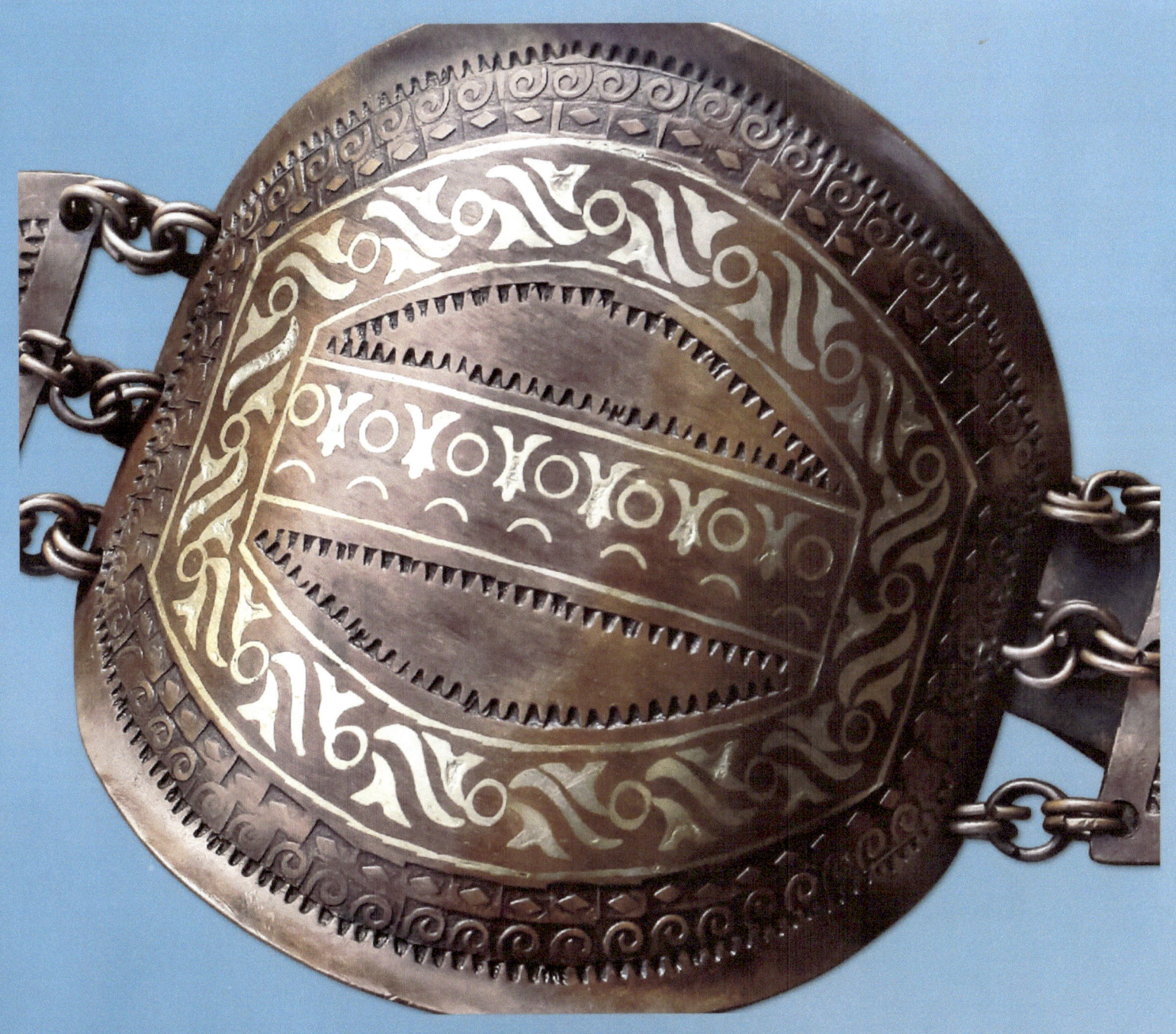

Royal Moro Queen's Knee Guards #12

Description: This royal queen's knee guards are made of bronze with an ornate pattern inlaid in silver. Each knee plate is connected by chain links.

Length: 5 ins Approximate Age: 1900's
Width: 5 ins Condition: Museum Quality

Location Purchased: Ebay
Location Found: Lake Lanao, Mindanao, Philippines

ROYAL COURT ARMOR of MOROLAND MUSEUM

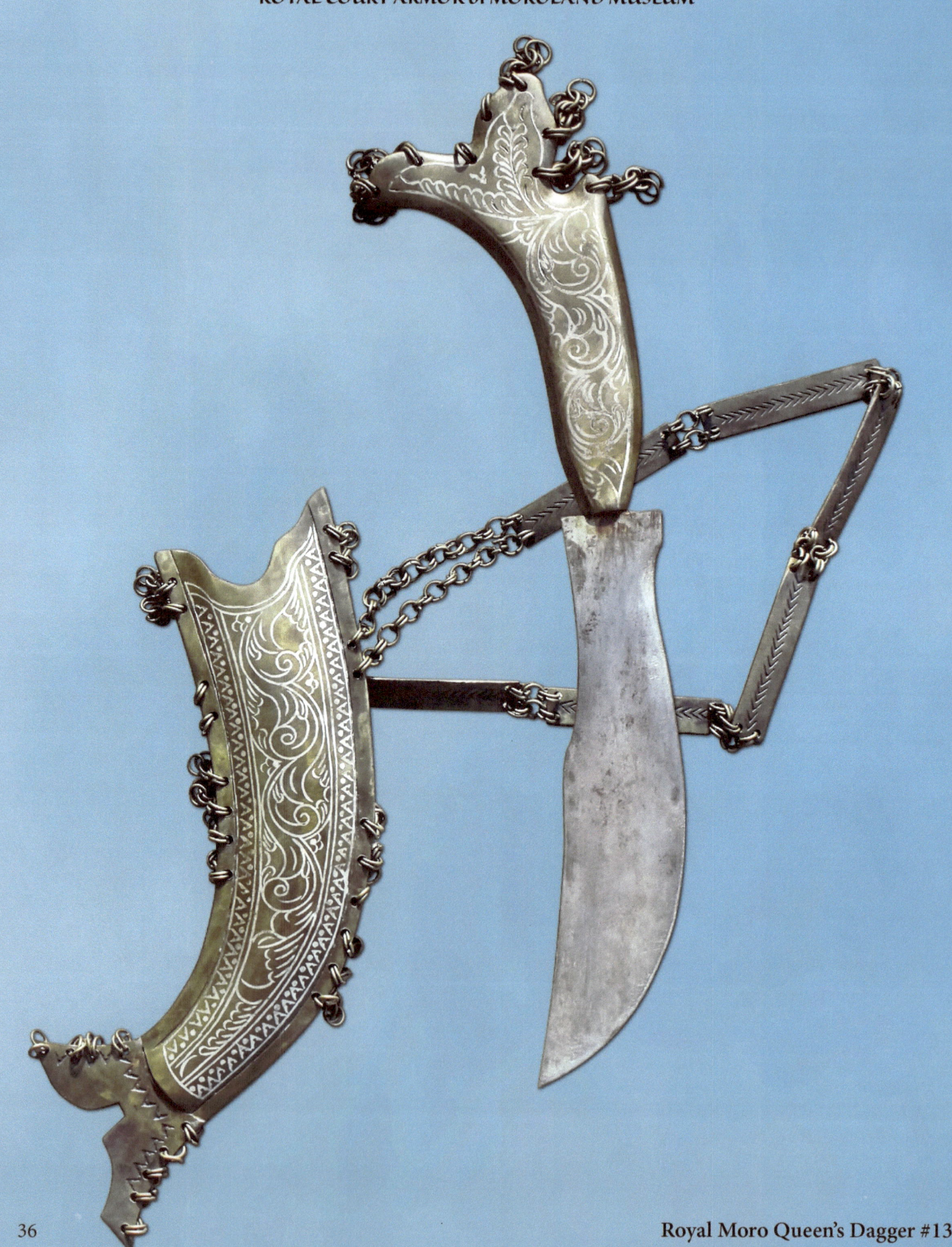

Royal Moro Queen's Dagger #13

ROYAL COURT ARMOR of MOROLAND MUSEUM

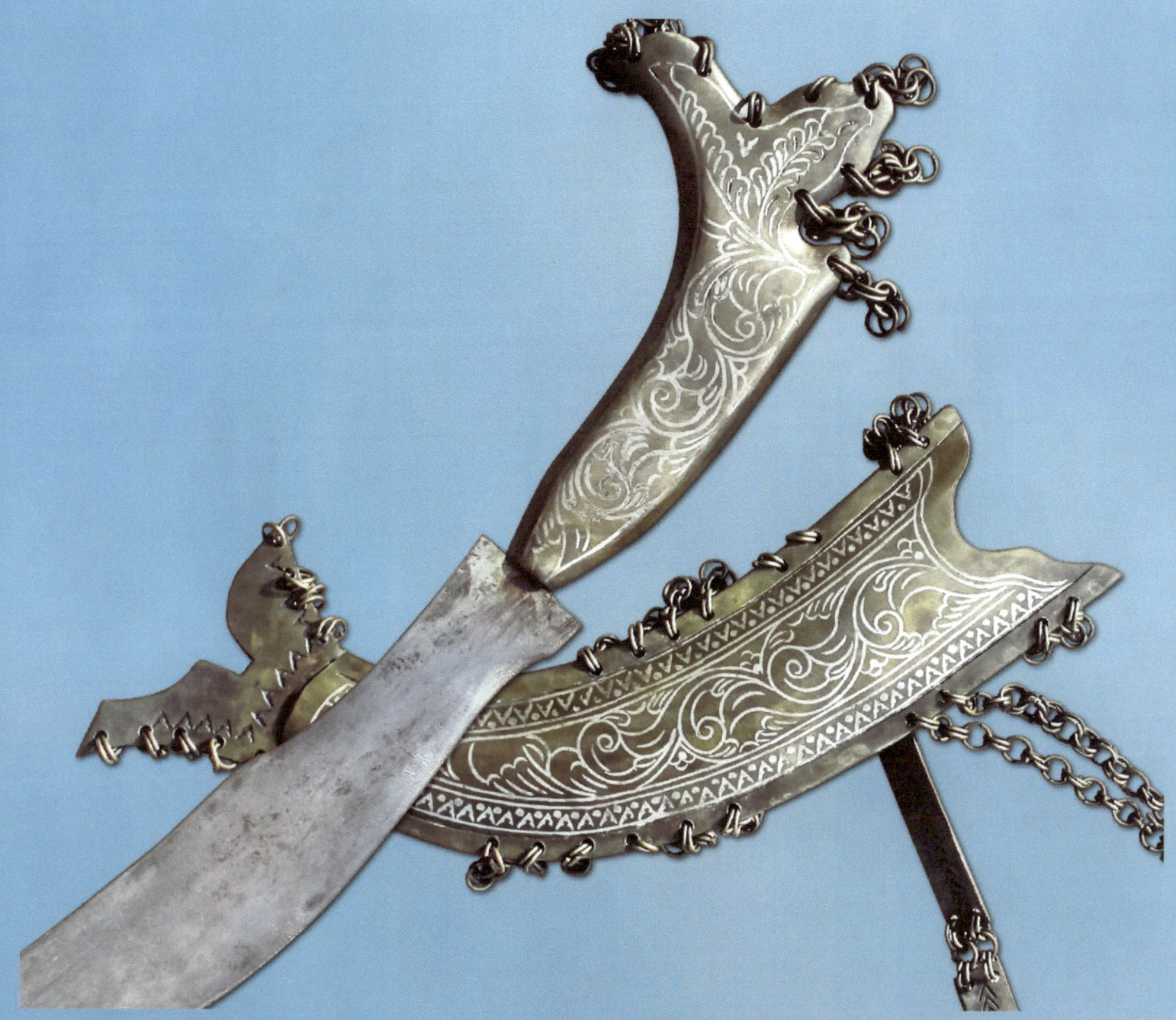

Royal Moro Queen's Dagger #13

Description: This royal queen's knife is made of bronze with an ornate silver inlay pattern. The belt is connected by pierced metal plates attached by chain links and has links lining the edges for decoration. The design on the dagger and scabbard is of the type that is customary of the Muslim influence that is present on most of the Moro weapons and artifacts found in this area.

Total Length:	14 ins	Blade: 9 ins	Approximate Age: 1900's
Total Widths:	5-3.5 ins		Condition: Museum Quality

Location Purchased: Ebay
Location Found: Lake Lanao, Mindanao, Philippines

ROYAL COURT ARMOR of MOROLAND MUSEUM

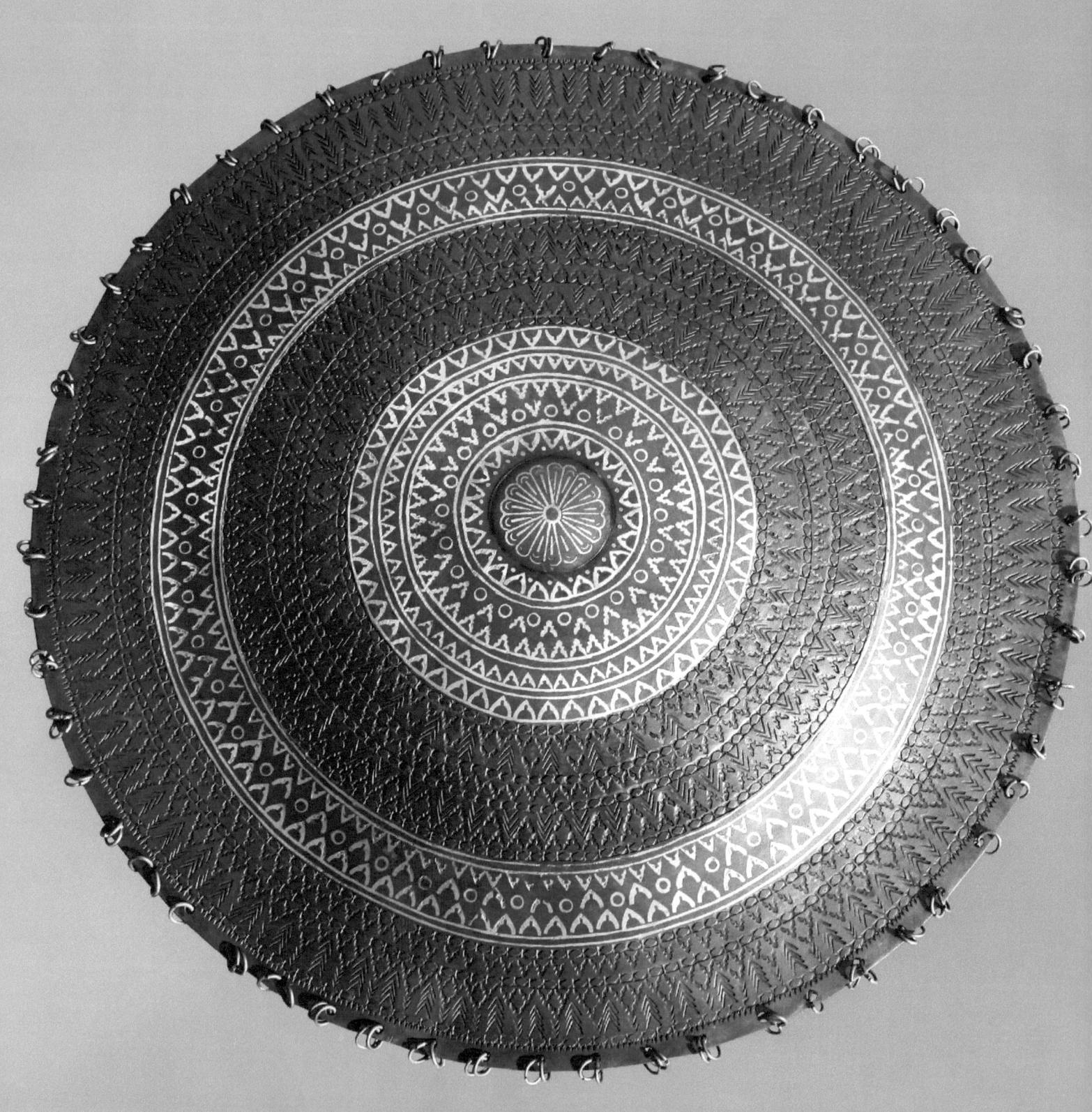

38

Royal Moro Queen's Round Shield #14

ROYAL COURT ARMOR of MOROLAND MUSEUM

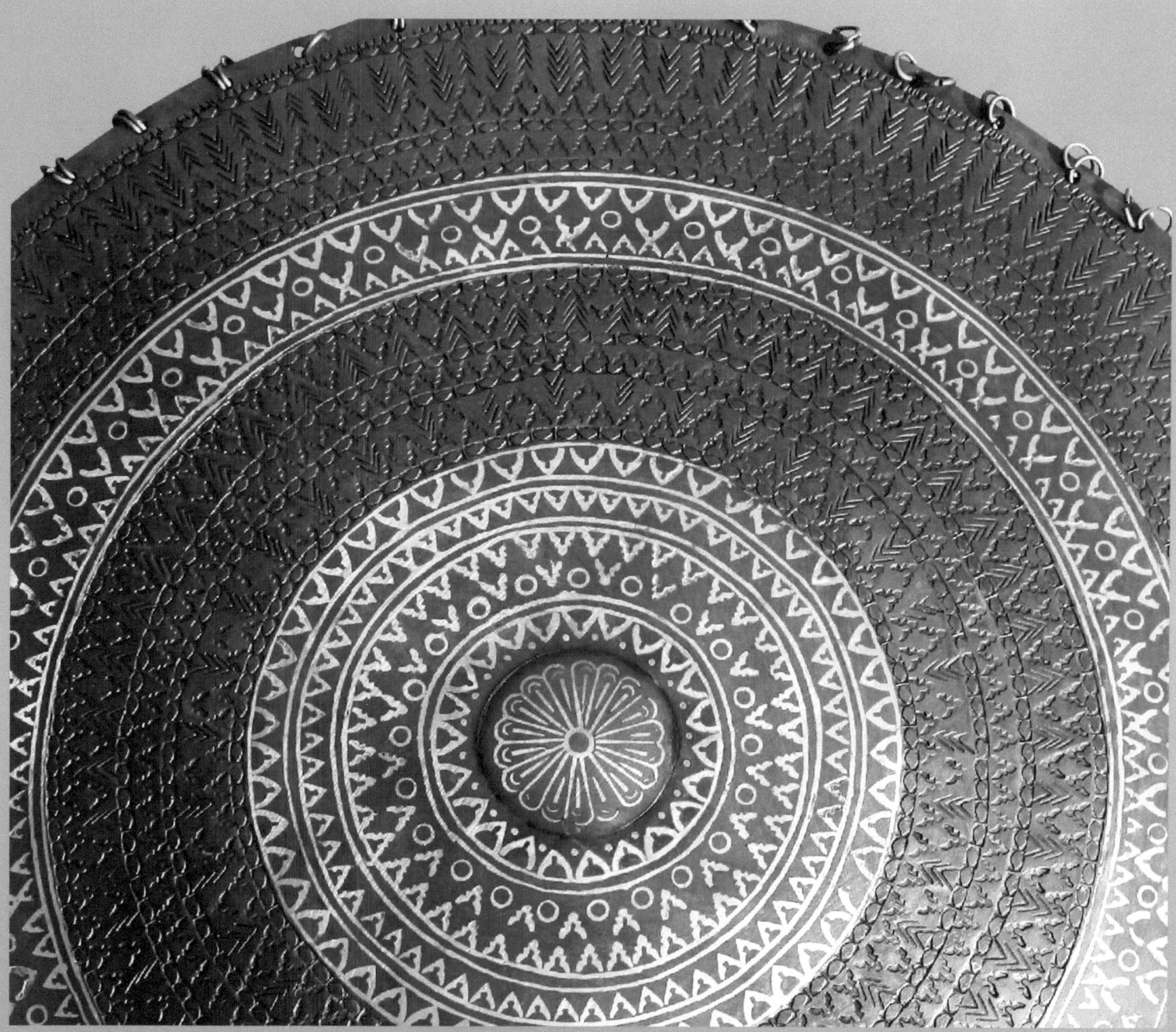

Royal Moro Queen's Round Shield #14

Description: This type of Royal Queen's round shield was used for sea warfare. These round style shields are made of bronze with ornate silver inlay patterns and has pierced metal surface with chain links attached. The inlay design shown is customary of the Muslim influence that is present in most of the Moro weapons and artifacts.

Circular Widths: 18 ins Approximate Age: 1900's
 Condition: Museum Quality

Location Purchased: Ebay
Location Found: Lake Lanao, Mindanao, Philippines

ROYAL COURT ARMOR of MOROLAND MUSEUM

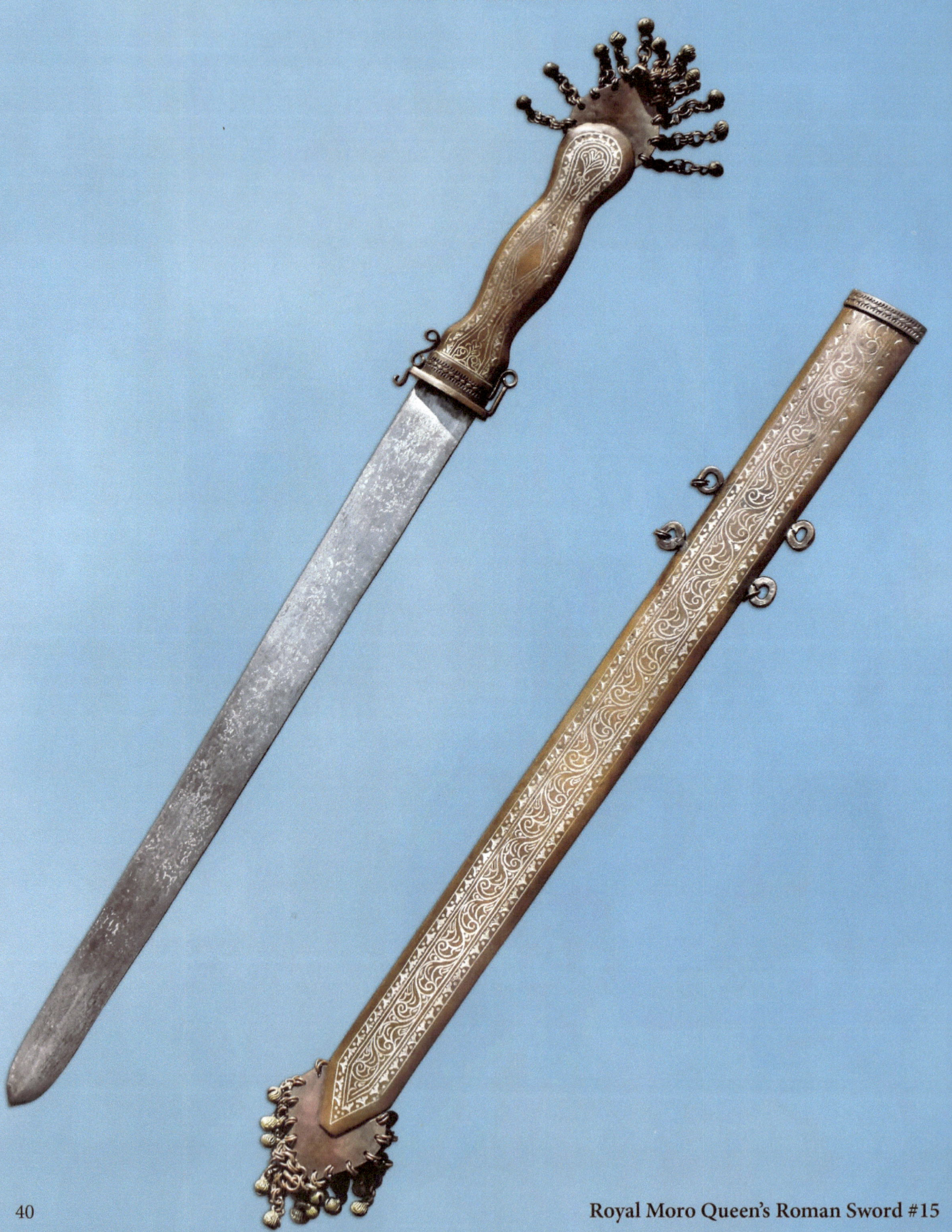

40 Royal Moro Queen's Roman Sword #15

ROYAL COURT ARMOR of MOROLAND MUSEUM

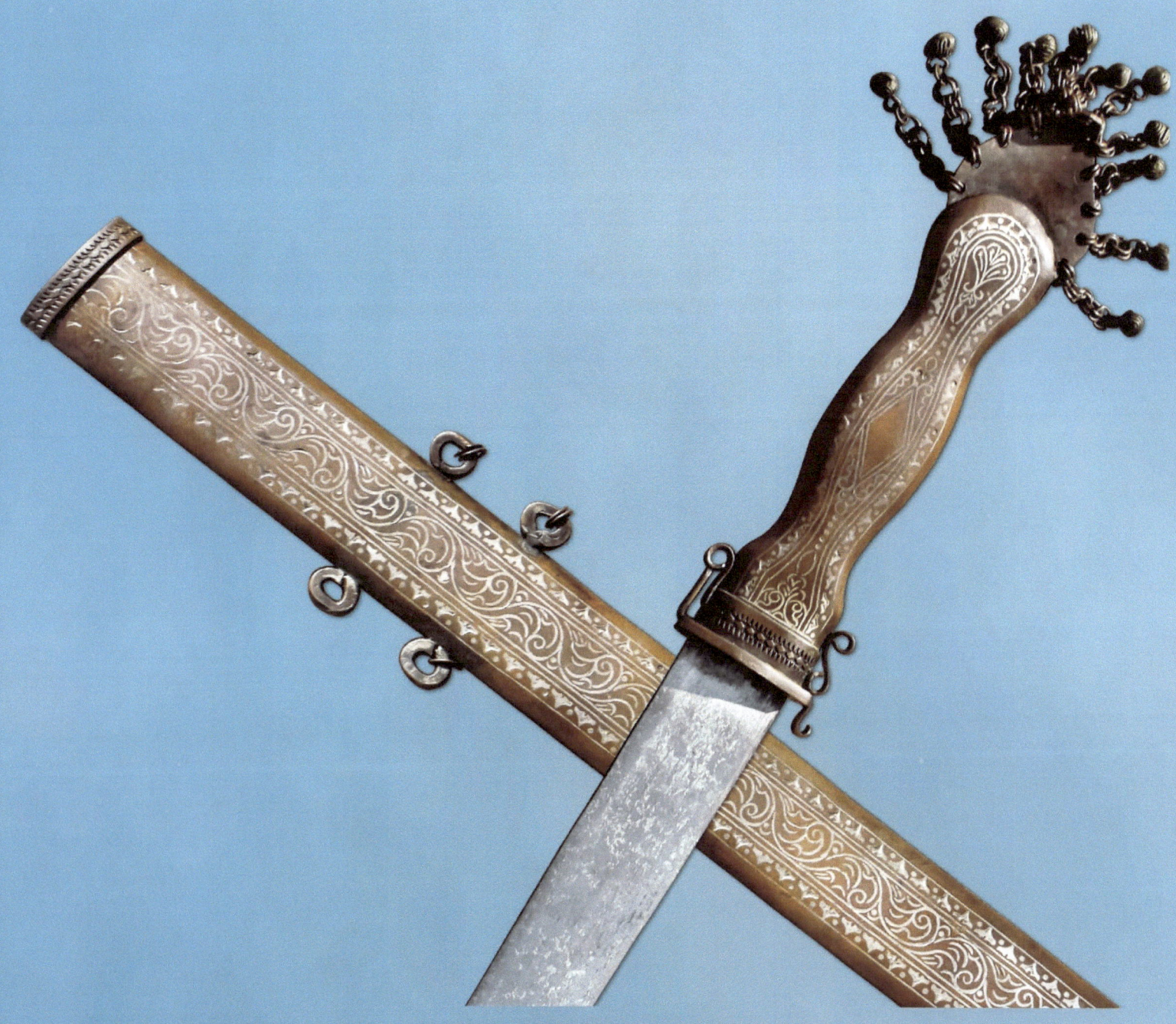

Royal Moro Queen's Roman Sword #15

Description: This royal queen's sword is designed after the straight roman style and made of bronze with an ornate silver inlaid pattern. Both the hilt and scabbard show the customary Muslim influence pattern that is present in most of the Moro weapons and artifacts found in this region of the Philippines.

Total Length:	38 ins	Blade:	28 ins	Approximate Age:	1900's
Total Widths:	3 ins	Blade:	2.5 ins	Condition:	Museum Quality

Location Purchased: Ebay
Location Found: Lake Lanao, Mindanao, Philippines

ROYAL COURT ARMOR of MOROLAND MUSEUM

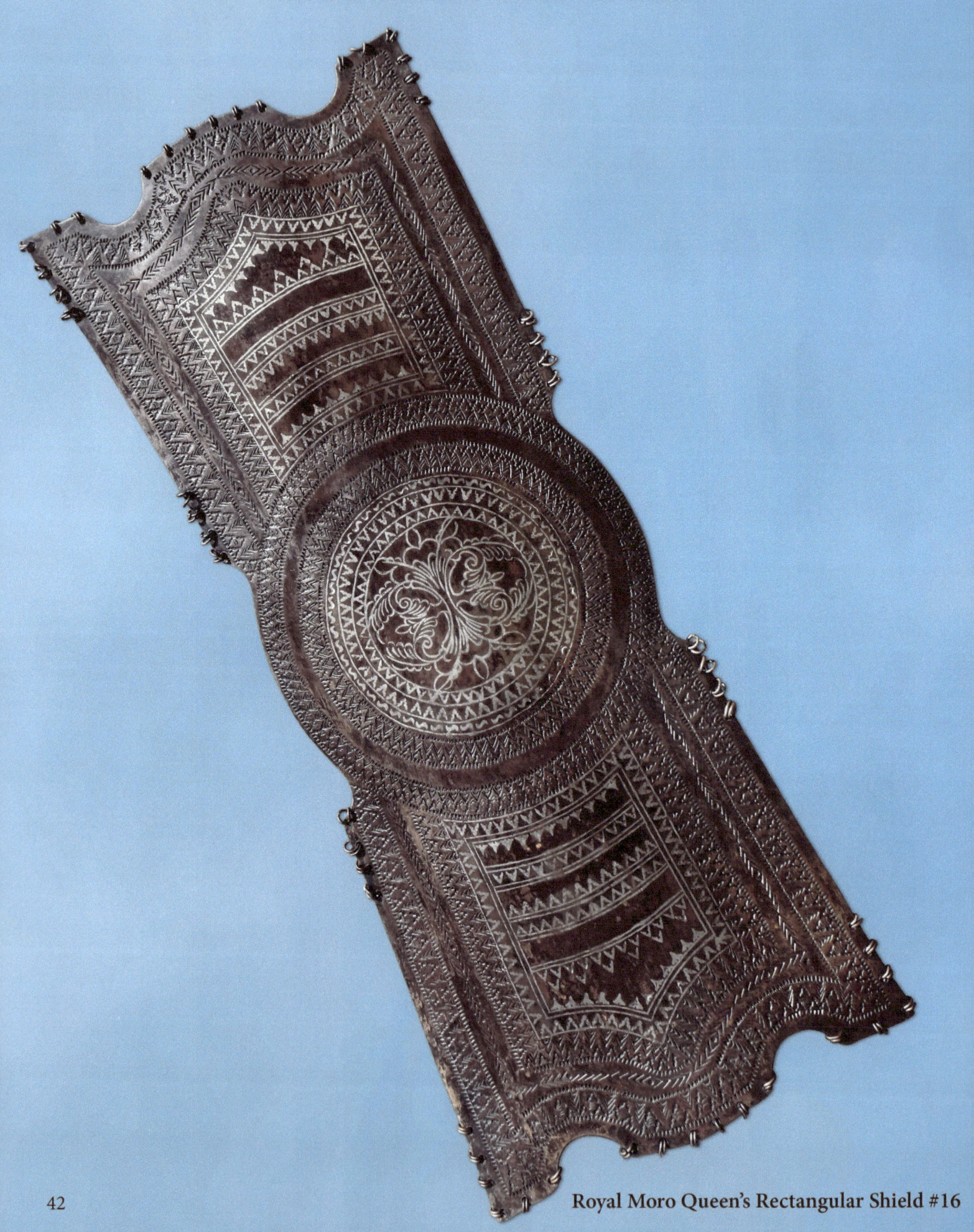

Royal Moro Queen's Rectangular Shield #16

ROYAL COURT ARMOR of MOROLAND MUSEUM

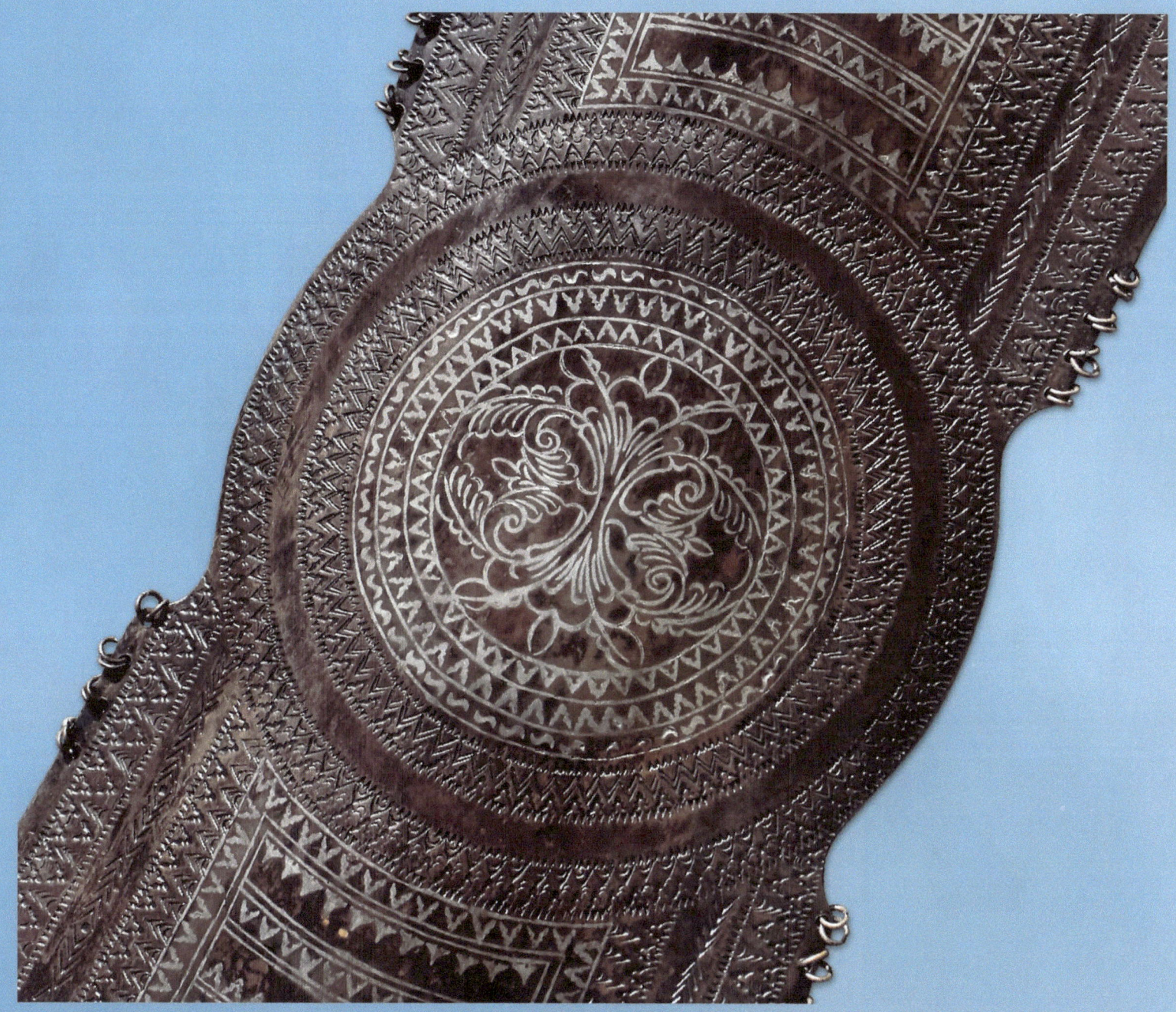

Royal Moro Queen's Rectangular Shield #16

Description: This type of Royal Queen's shield was used for land warfare. These rectangular style shields are made of bronze with ornate silver inlay patterns and has pierced metal surface with chain links attached. The inlay design shown is customary of the Muslim influence that is present in most of the Moro weapons and artifacts.

Length: 25 ins Approximate Age: 1900's
Small - Large Widths: 10-12 ins Condition: Museum Quality

Location Purchased: Ebay
Location Found: Lake Lanao, Mindanao, Philippines

ROYAL COURT ARMOR of MOROLAND MUSEUM

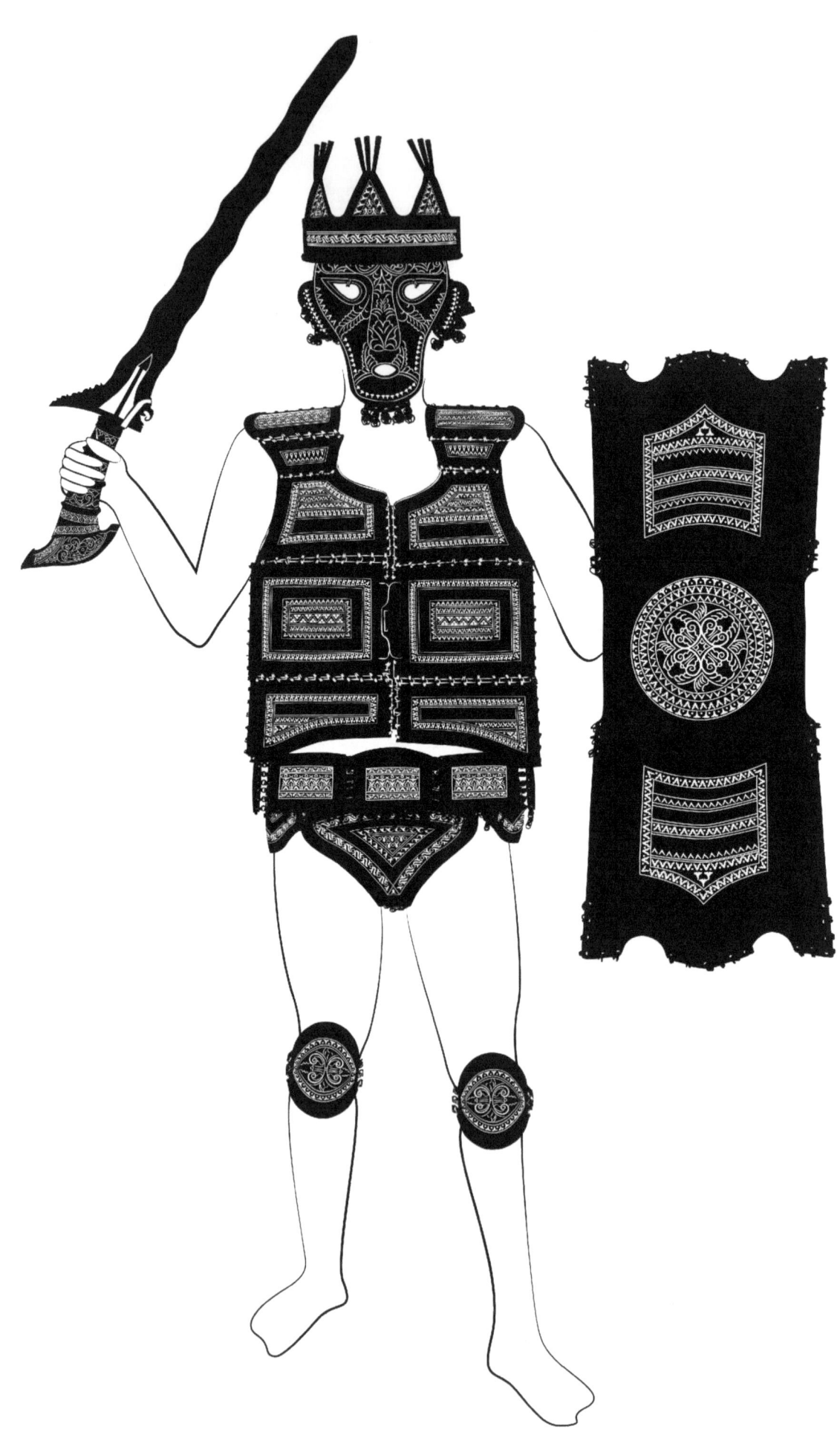

ROYAL COURT ARMOR of MOROLAND MUSEUM

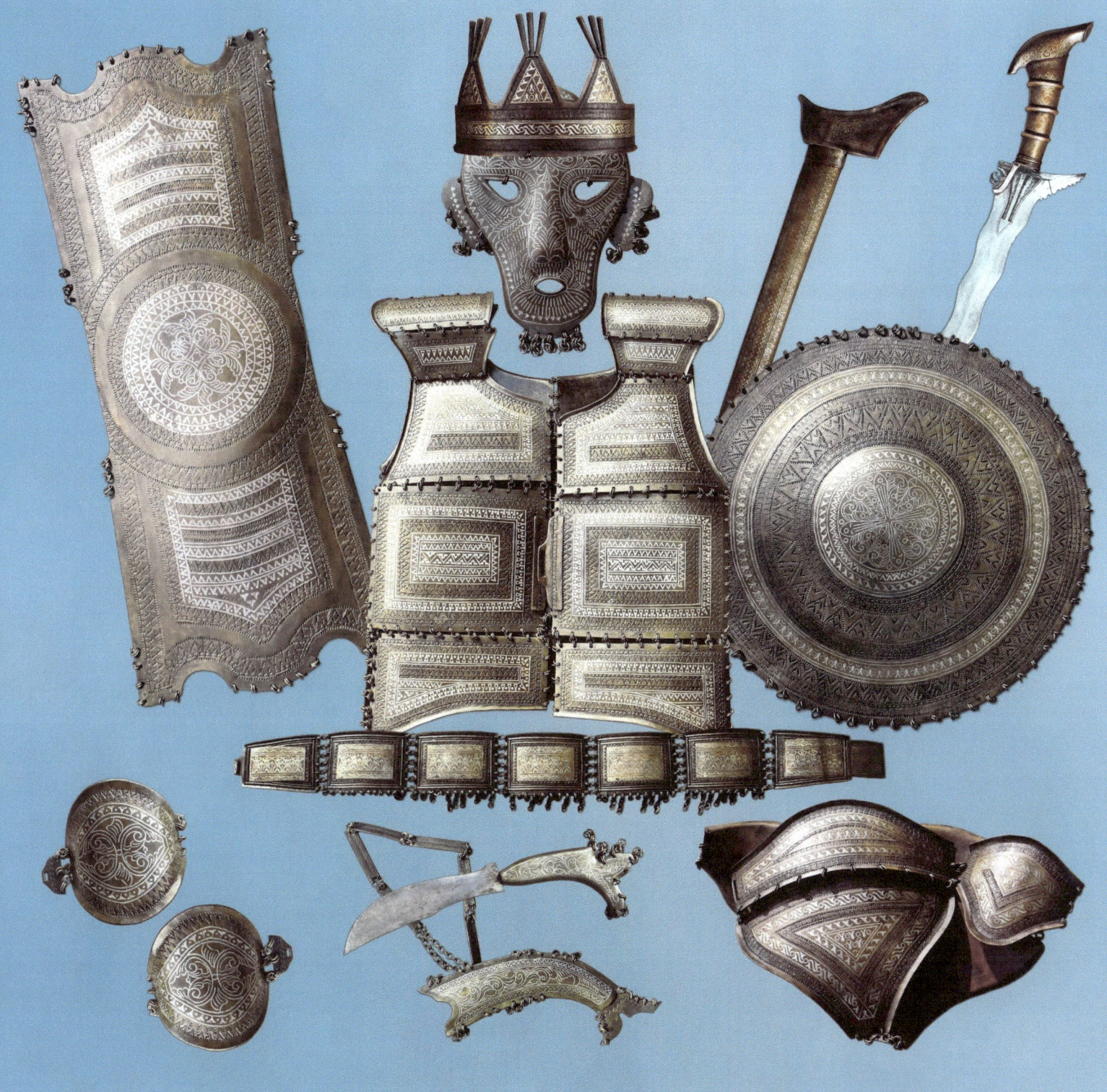

The Royal Moro King's Set of Armor : #03

 The third set of armor is the Royal Moro King's set of Armor. This set of Royal Moro Armor consists of a King's Crown, King's Mask, King's Vest, King's Wealth Belt, King's Groin Protector, King's Knee Guards, King's Ceremonial Sword (Keris), King's Rectangular Shield, King's Dagger, and a King's Round Shield. This Royal set of armor is made of bronze with silver inlay. It was crafted for display purposes to show wealth and power, instead of use in actual combat. This is a very rare suit of Royal Moro Kings' armor.

ROYAL COURT ARMOR of MOROLAND MUSEUM

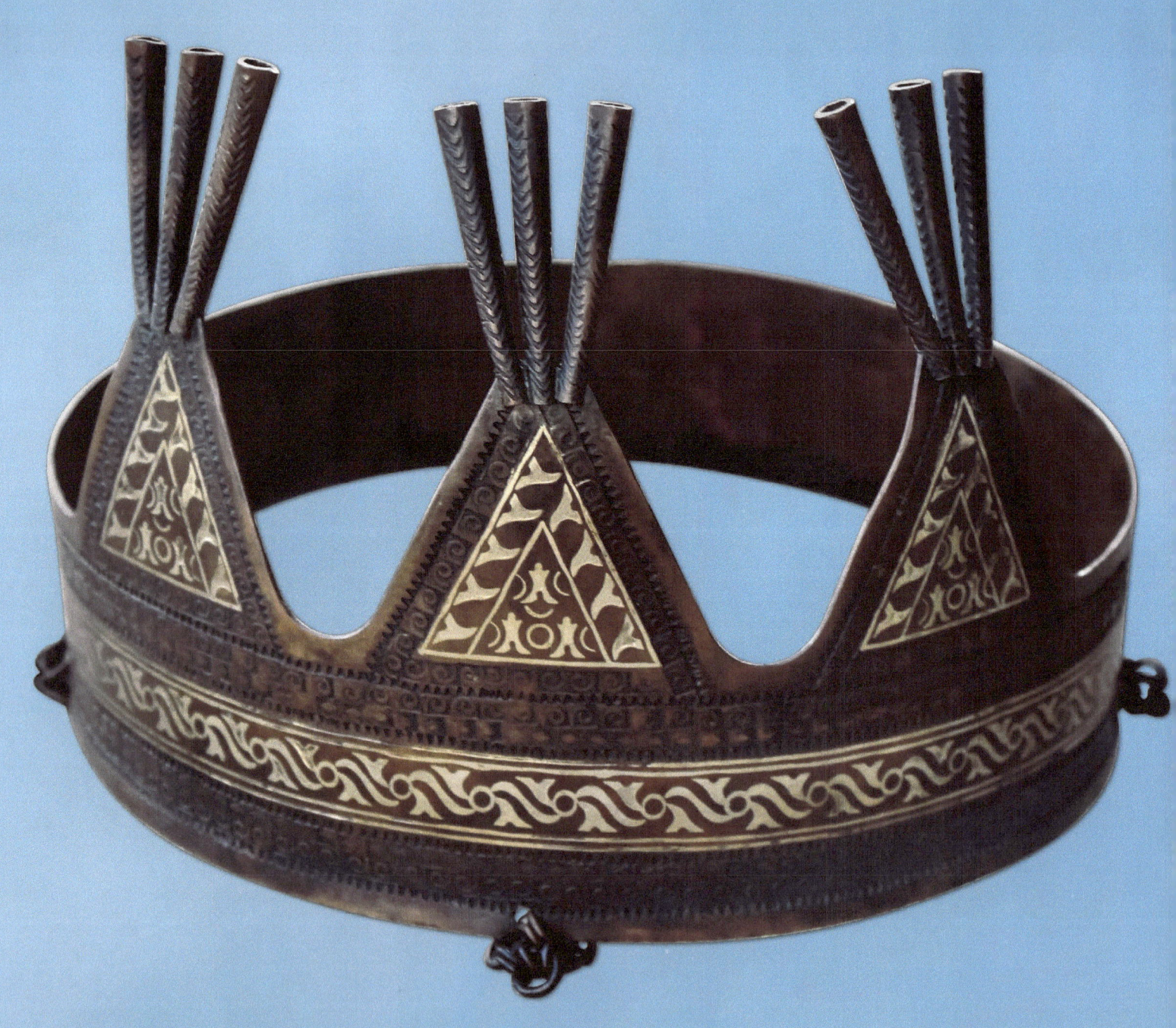

Royal Moro King's Crown #17

ROYAL COURT ARMOR of MOROLAND MUSEUM

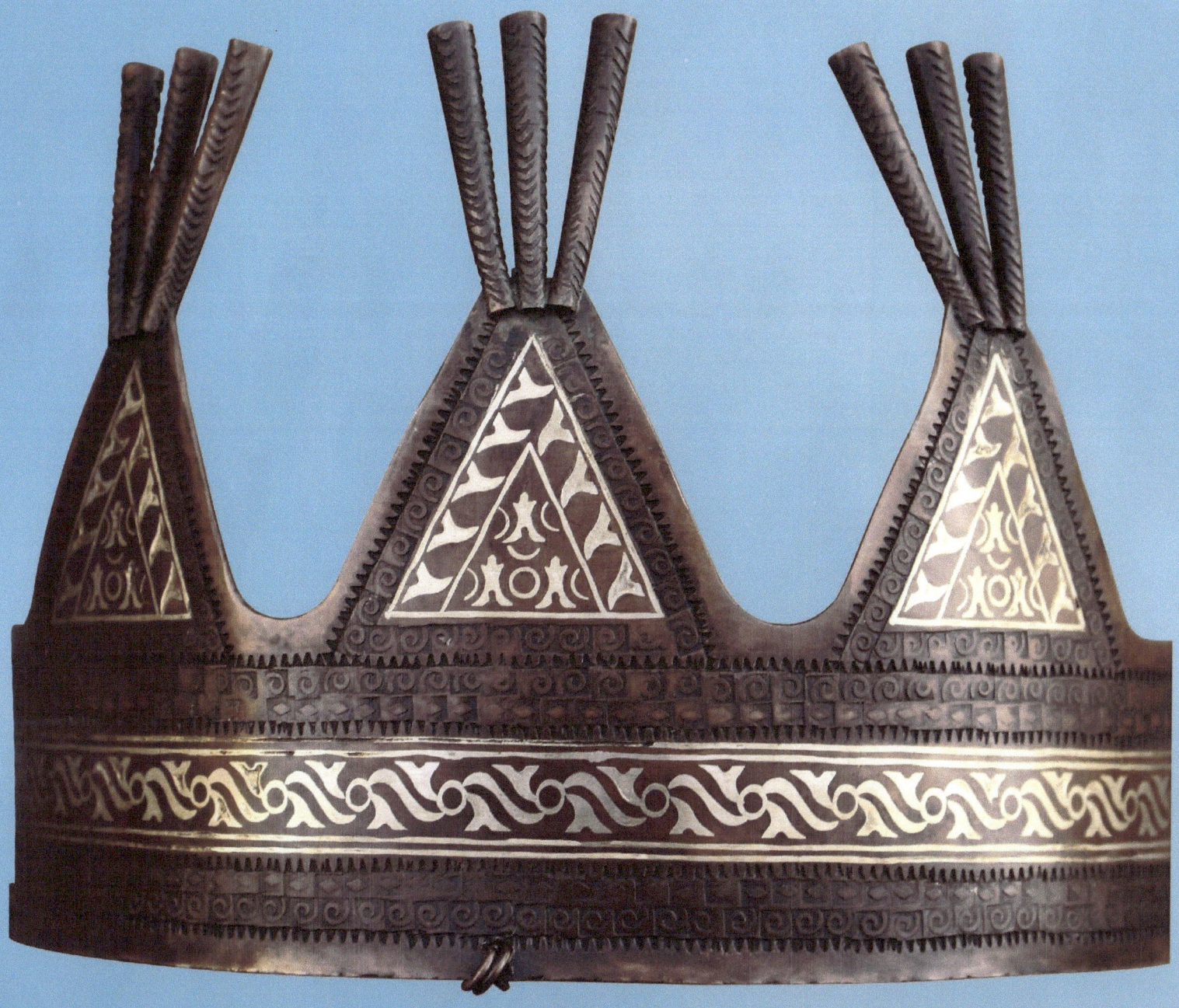

Royal Moro King's Crown #17

Description: This royal king's crown is made of bronze with an ornate silver inlaid pattern. It is edged with metal chain links that creates a cross hatch to hold the crown on the kings' head. The top front is shaped with three Triangle Tee-pee like designs and the same silver inlaid pattern as the headband.

Circular Widths:	12 ins	Approximate Age:	1900's
Total Heights:	9 ins	Condition:	Museum Quality

Location Purchased: Ebay
Location Found: Lake Lanao, Mindanao, Philippines

ROYAL COURT ARMOR of MOROLAND MUSEUM

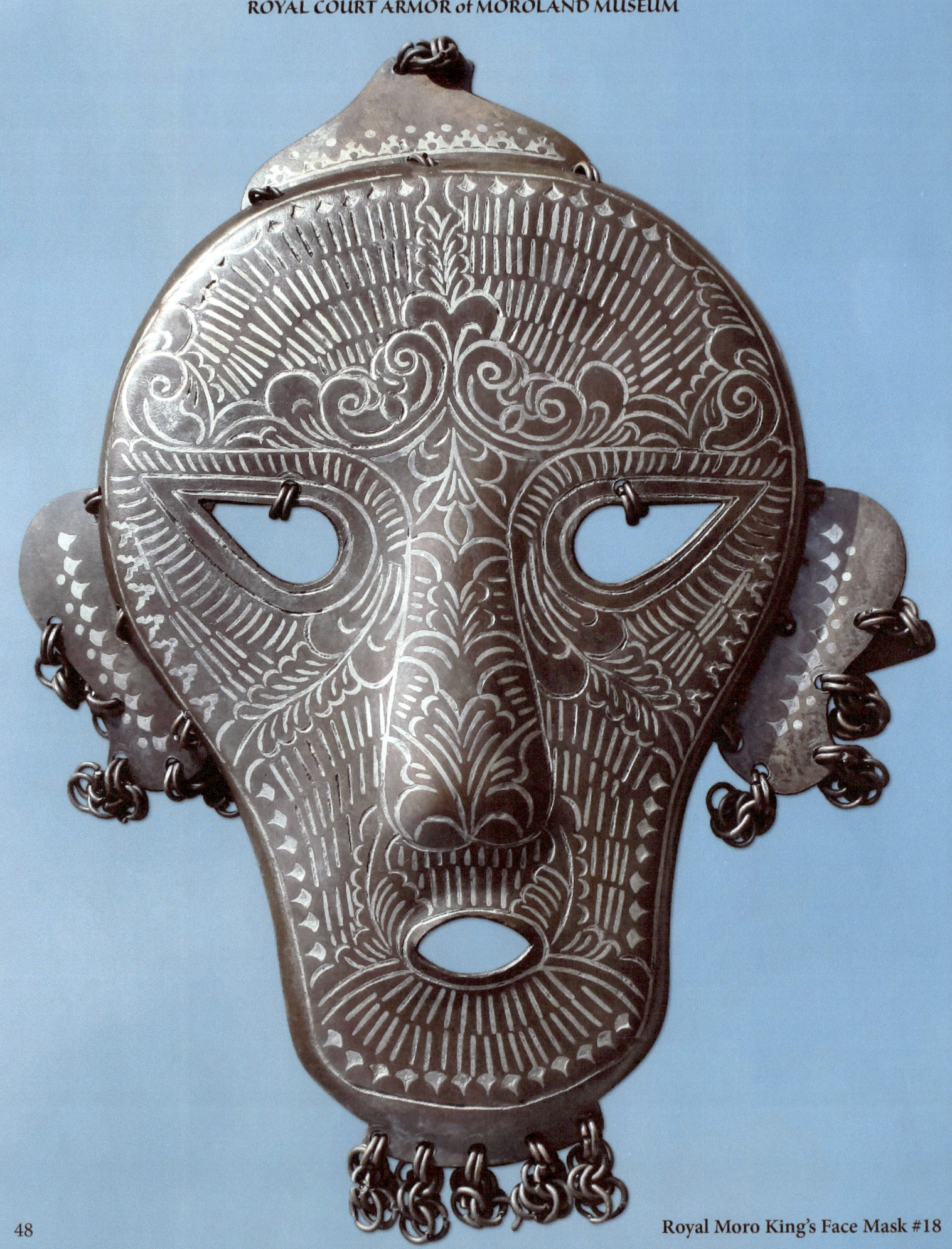

Royal Moro King's Face Mask #18

ROYAL COURT ARMOR of MOROLAND MUSEUM

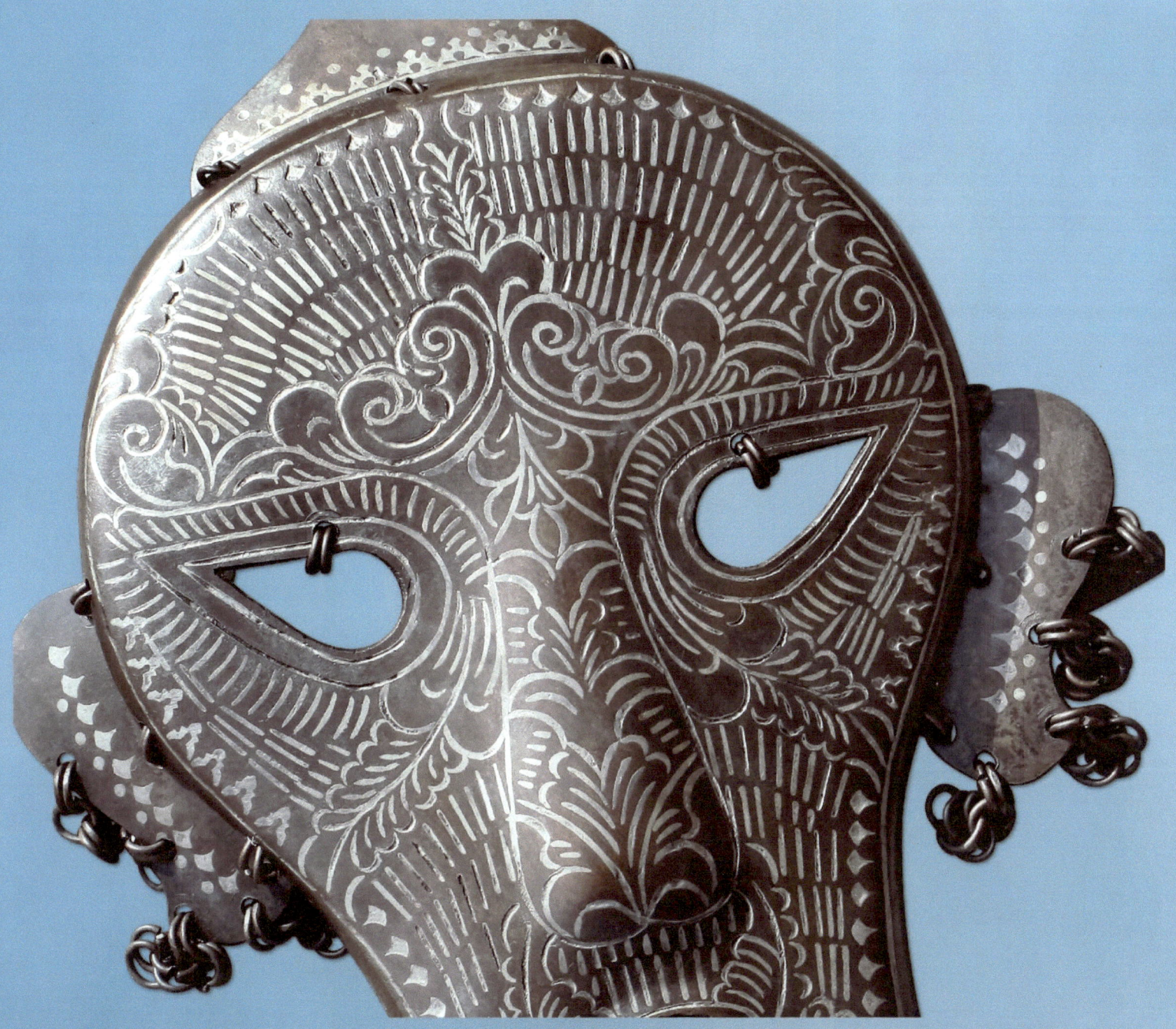

Royal Moro King's Face Mask #18

Description: This royal king's face mask is made of bronze with an ornate pattern inlaid in silver. The head and ear protectors are connected with chain links, while short chain links hang off the ears and chin.

Total Length: 9 ins Approximate Age: 1900's
Total Widths: 7 ins Condition: Museum Quality

Location Purchased: Ebay
Location Found: Lake Lanao, Mindanao, Philippines

ROYAL COURT ARMOR of MOROLAND MUSEUM

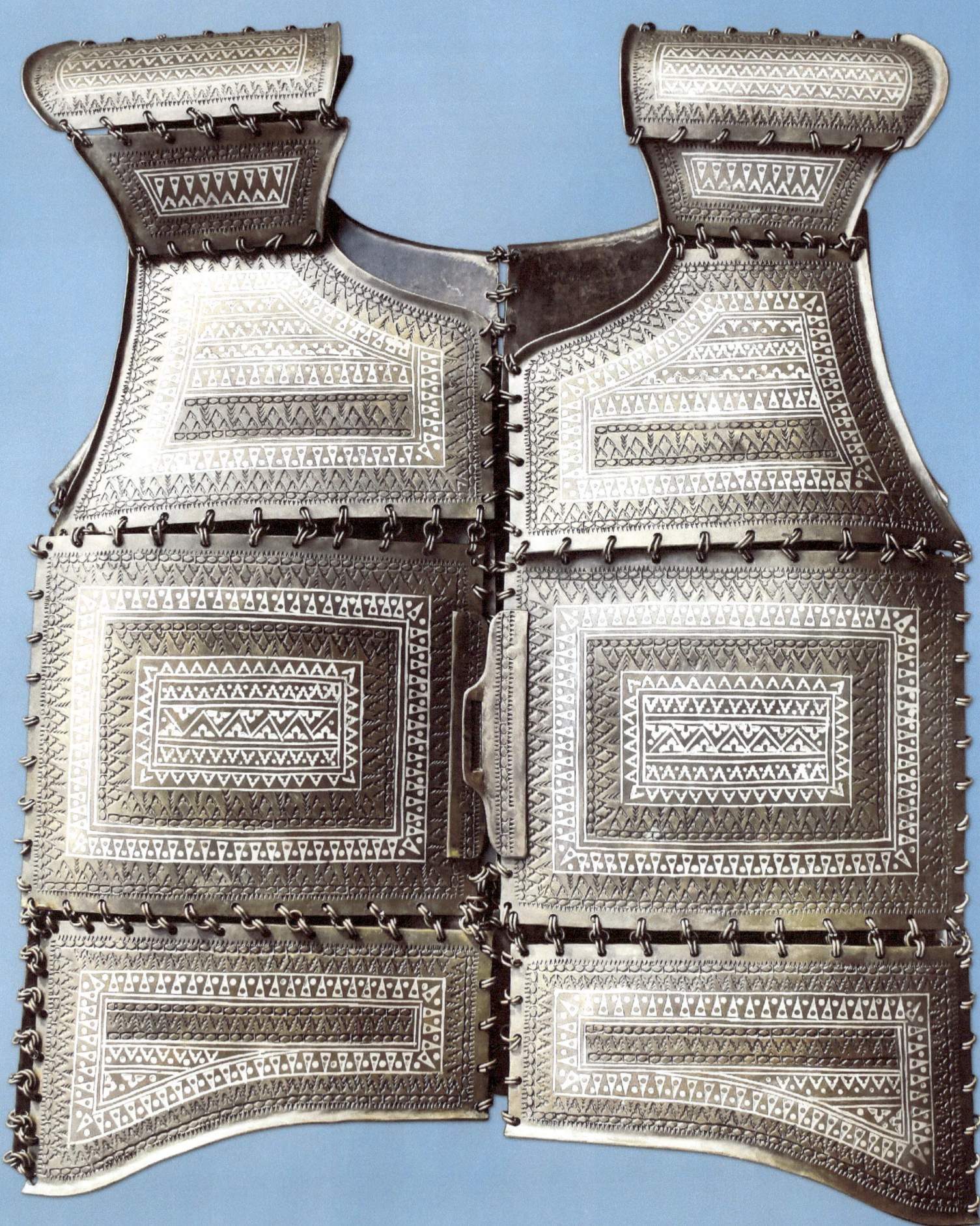

Royal Moro King's Vest #19

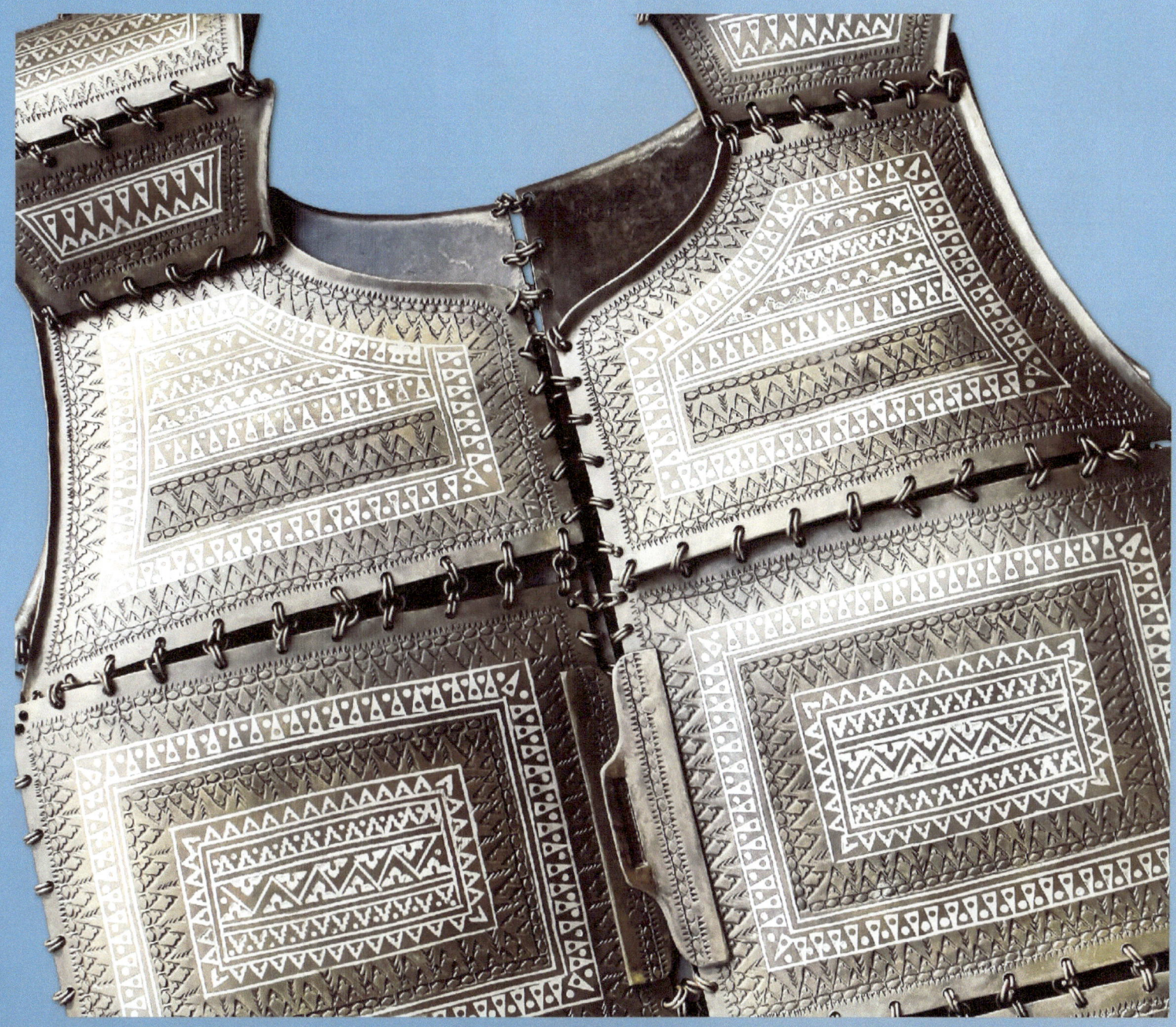

Royal Moro King's Vest #19

Description: This royal king's combat vest is made out of bronze with an ornate pattern inlaid in silver. This vest is a little heavy in weight since each metal plate is attached by chain links.

Length: 22 ins Approximate Age: 1900's
Width: 15 ins Condition: Museum Quality

Location Purchased: Ebay
Location Found: Lake Lanao, Mindanao, Philippines

ROYAL COURT ARMOR of MOROLAND MUSEUM

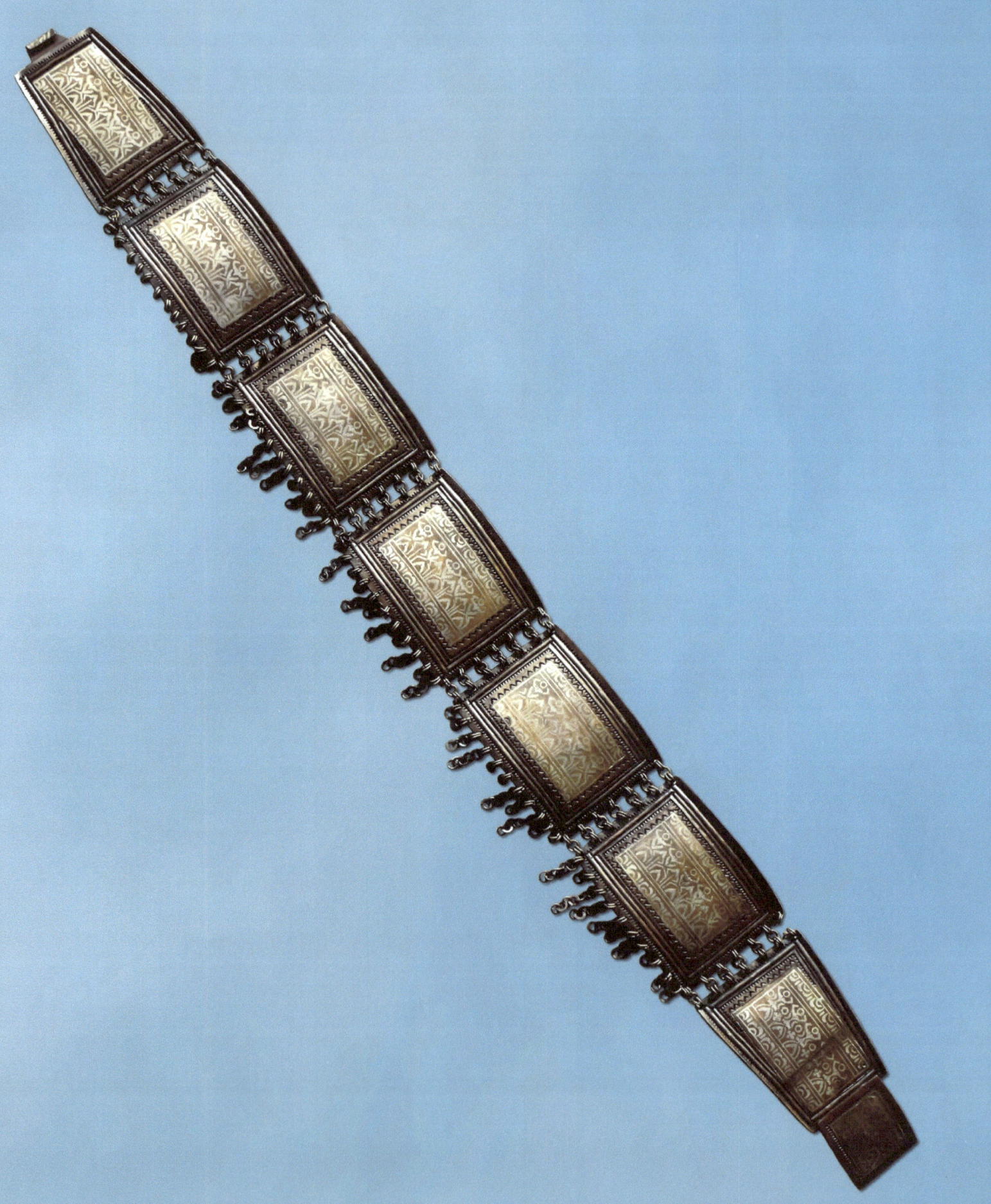

Royal Moro King's Wealth Belt #20

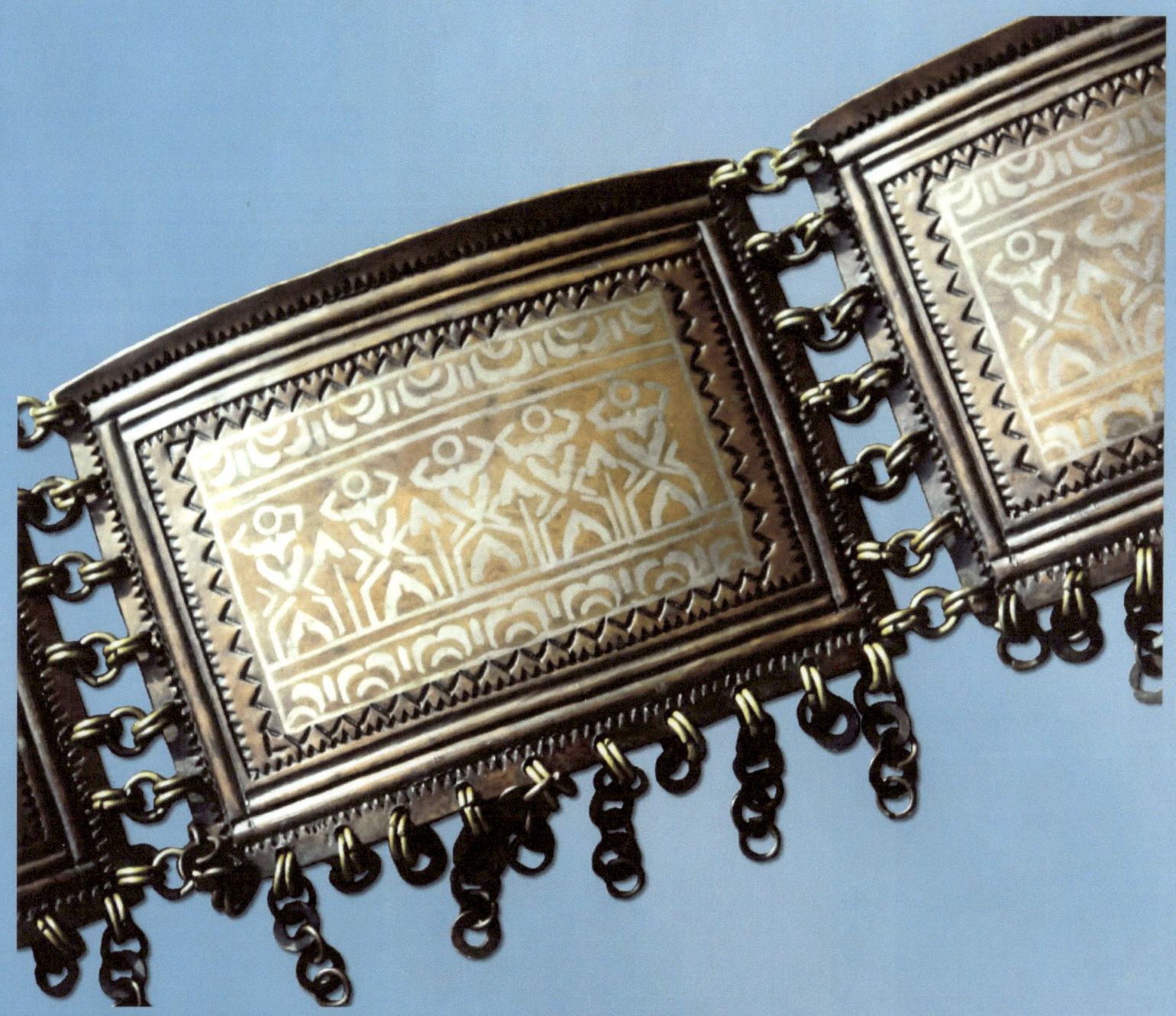

Royal Moro King's Wealth Belt #20

Description: This royal wealth belt is made out of bronze with an ornate pattern inlaid in silver. These types of belts were made for a display of power and wealth. This belt consists of eight separate bronze metal plates attached by chain links and the middle five are edged along the bottom with chain links.

Length:	50 ins	Approximate Age:	1900's
Width:	7 ins	Condition:	Museum Quality

Location Purchased: Ebay
Location Found: Lake Lanao, Mindanao, Philippines

ROYAL COURT ARMOR of MOROLAND MUSEUM

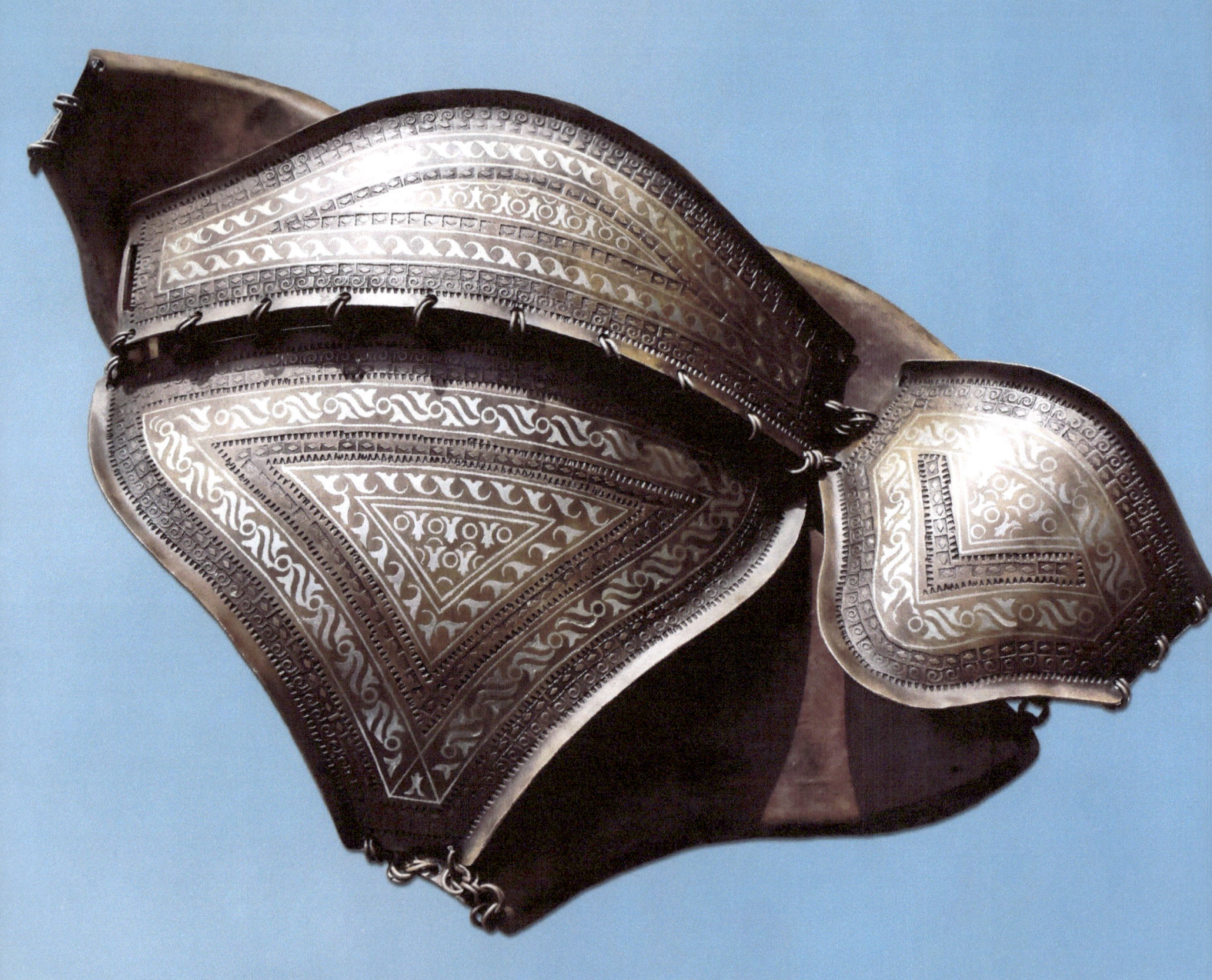

Royal Moro King's Groin Protector #21

ROYAL COURT ARMOR of MOROLAND MUSEUM

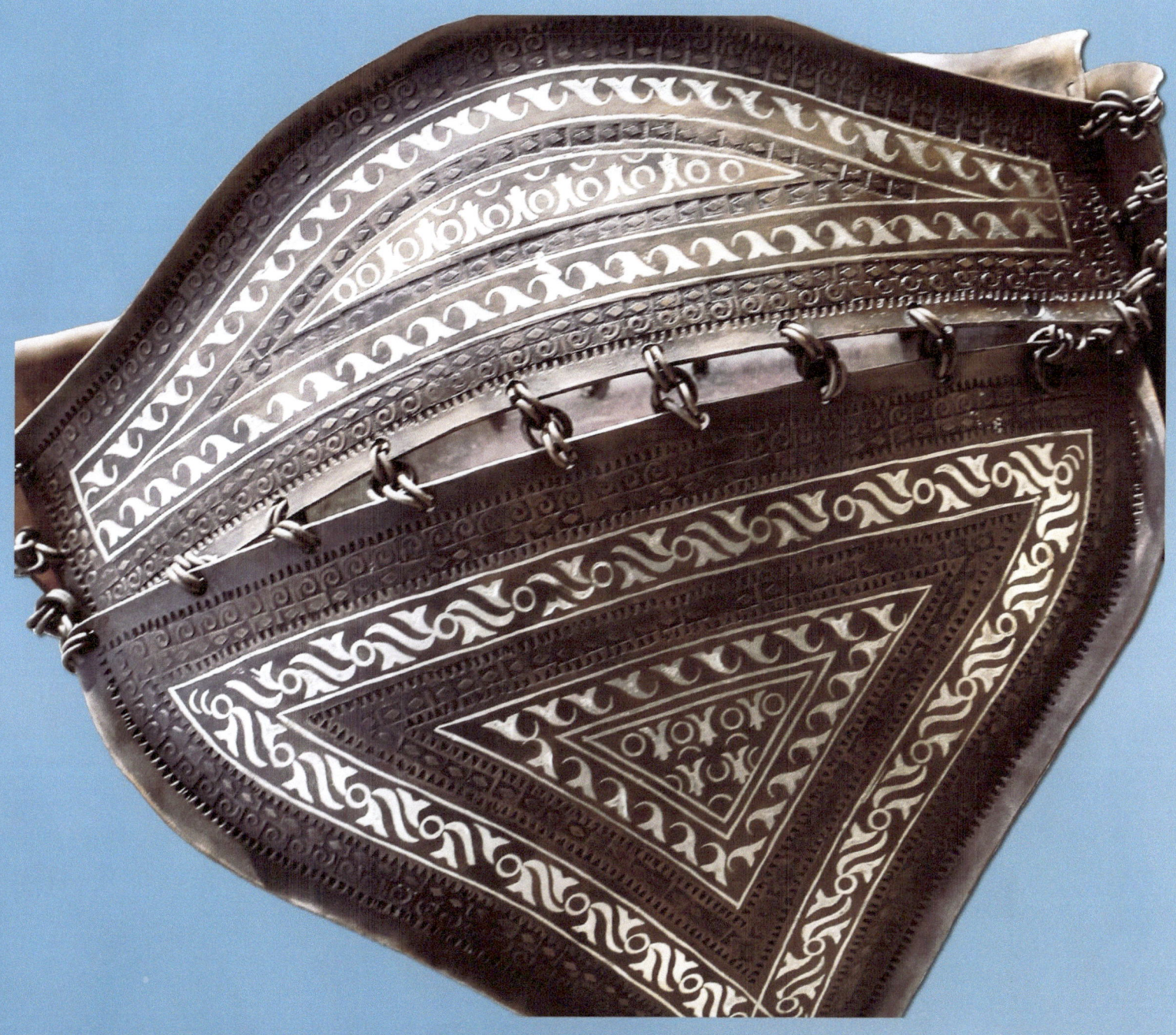

Royal Moro King's Groin Protector #21

Description: This royal king's groin protector is made of bronze with an ornate pattern inlaid in silver. The metal plates are connected entirely by chain links.

Main Panels Side Panels
Length: 14 ins Length: 14 ins Approximate Age: 1900's
Width: 16 ins Width: 16 ins Condition: Museum Quality

Location Purchased: Ebay
Location Found: Lake Lanao, Mindanao, Philippines

ROYAL COURT ARMOR of MOROLAND MUSEUM

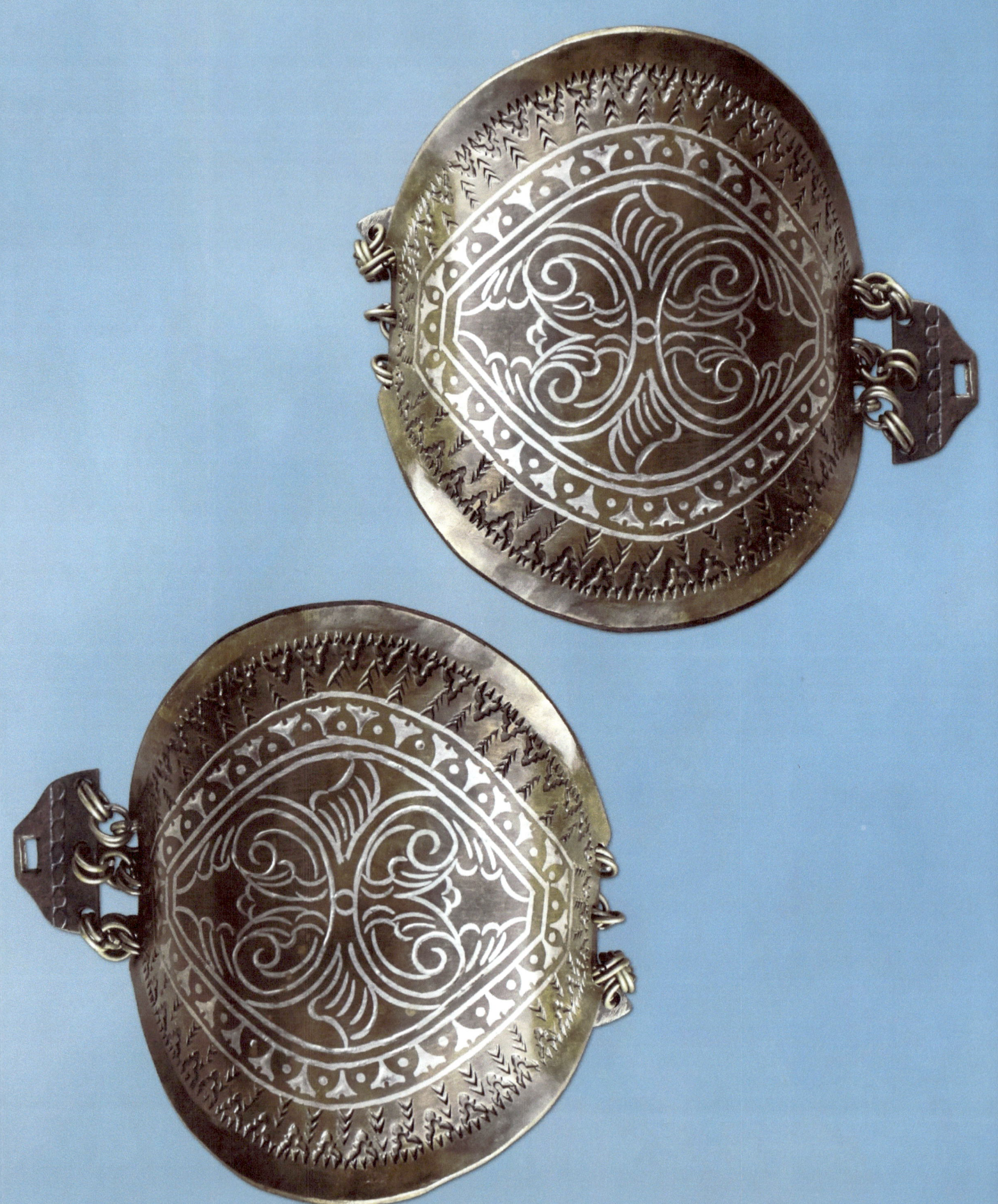

Royal Moro King's Knee Guards #22

ROYAL COURT ARMOR of MOROLAND MUSEUM

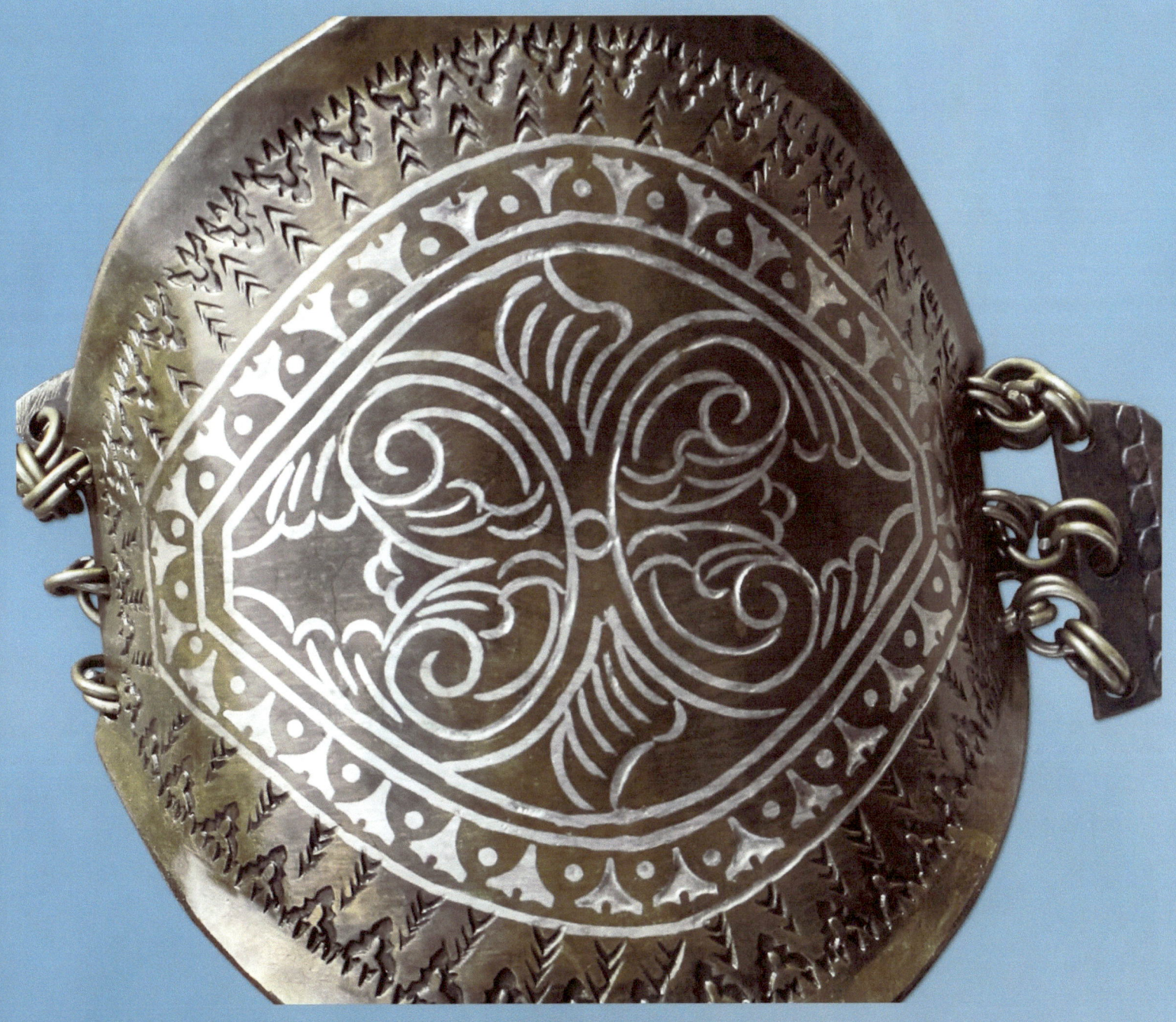

Royal Moro King's Knee Guards #22

Description: This royal king's knee guards are made of bronze with an ornate pattern inlaid in silver. Each knee plate is connected by chain links.

Length: 5 ins Approximate Age: 1900's
Width: 5 ins Condition: Museum Quality

Location Purchased: Ebay
Location Found: Lake Lanao, Mindanao, Philippines

ROYAL COURT ARMOR of MOROLAND MUSEUM

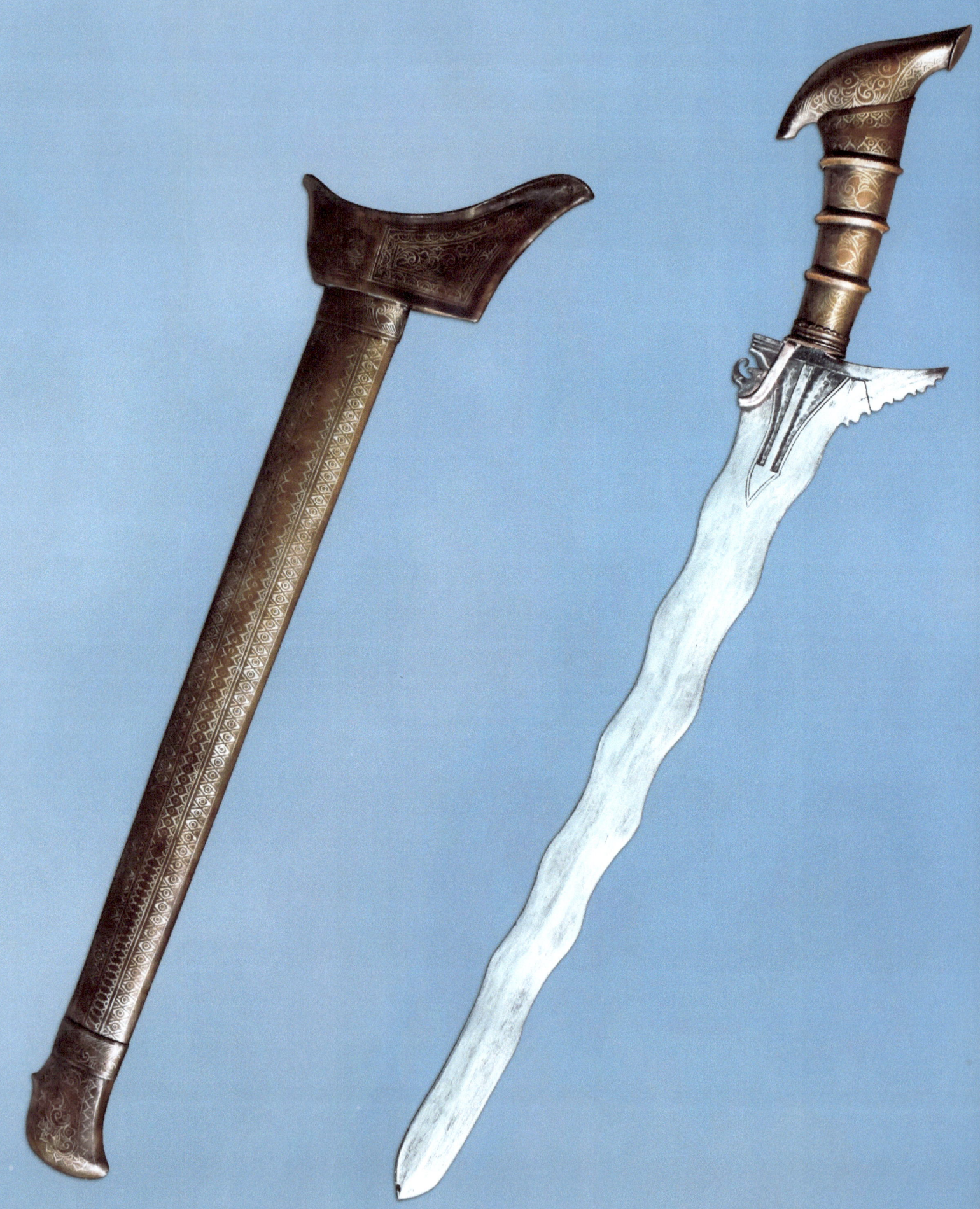

Royal Moro King's Keris #23

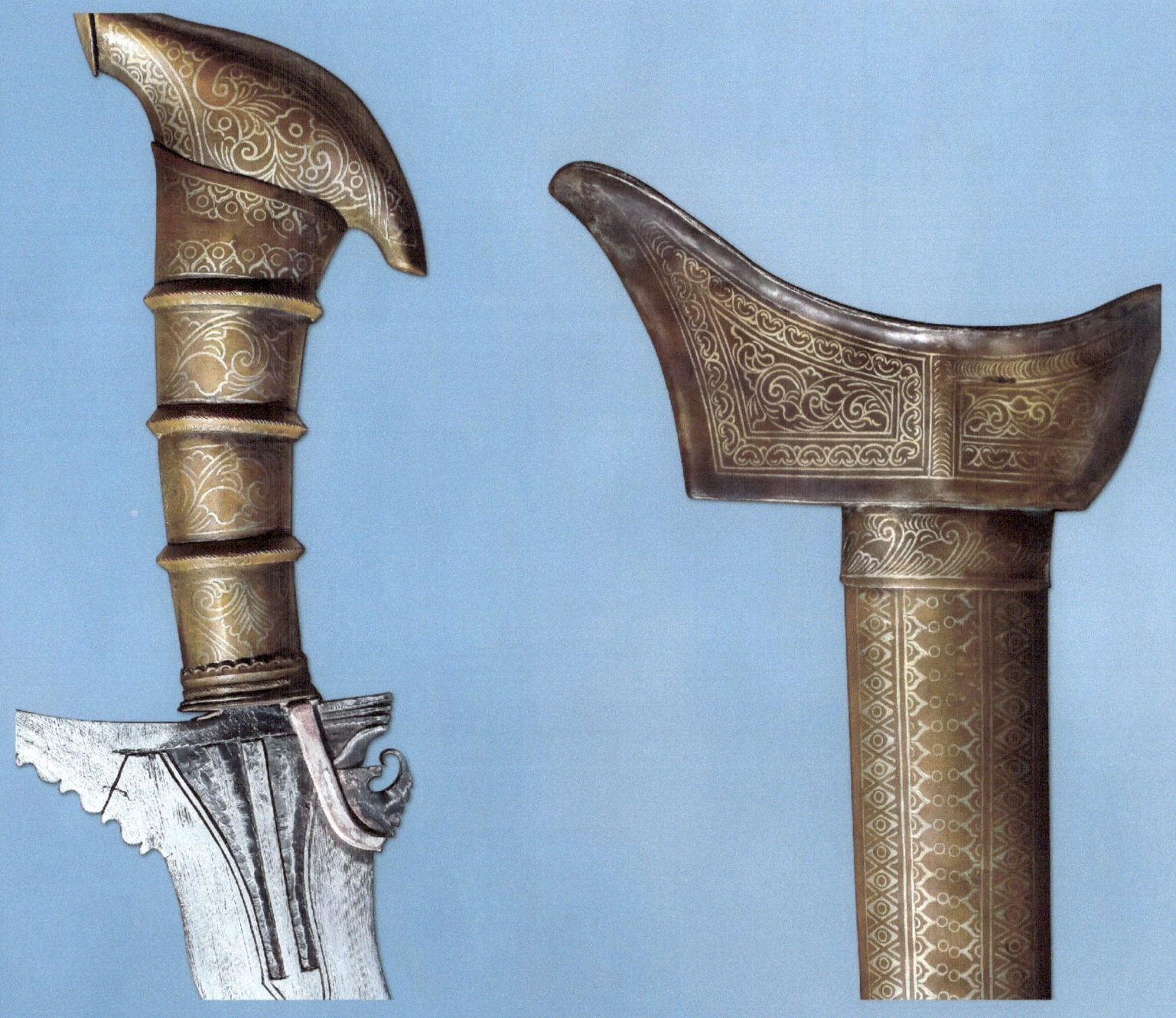

Royal Moro King's Keris #23

Description: This royal king's keris (sword) is made of bronze with an ornate gold inlaid pattern. The blade is wavy with a silver Moro band and a blood chevron starting near the handle of the sword heading about 4 inches towards the end of the blade. Both the hilt and scabbard show the customary Muslim influence pattern that is present in most of the Moro weapons and artifacts found in this region of the Philippines.

Total Length: 39 ins Blade: 27 ins Approximate Age: 1900's
Total Widths: 3.5 - 7 ins Blade: 2.5 - 4 ins Condition: Museum Quality

Location Purchased: Ebay
Location Found: Lake Lanao, Mindanao, Philippines

ROYAL COURT ARMOR of MOROLAND MUSEUM

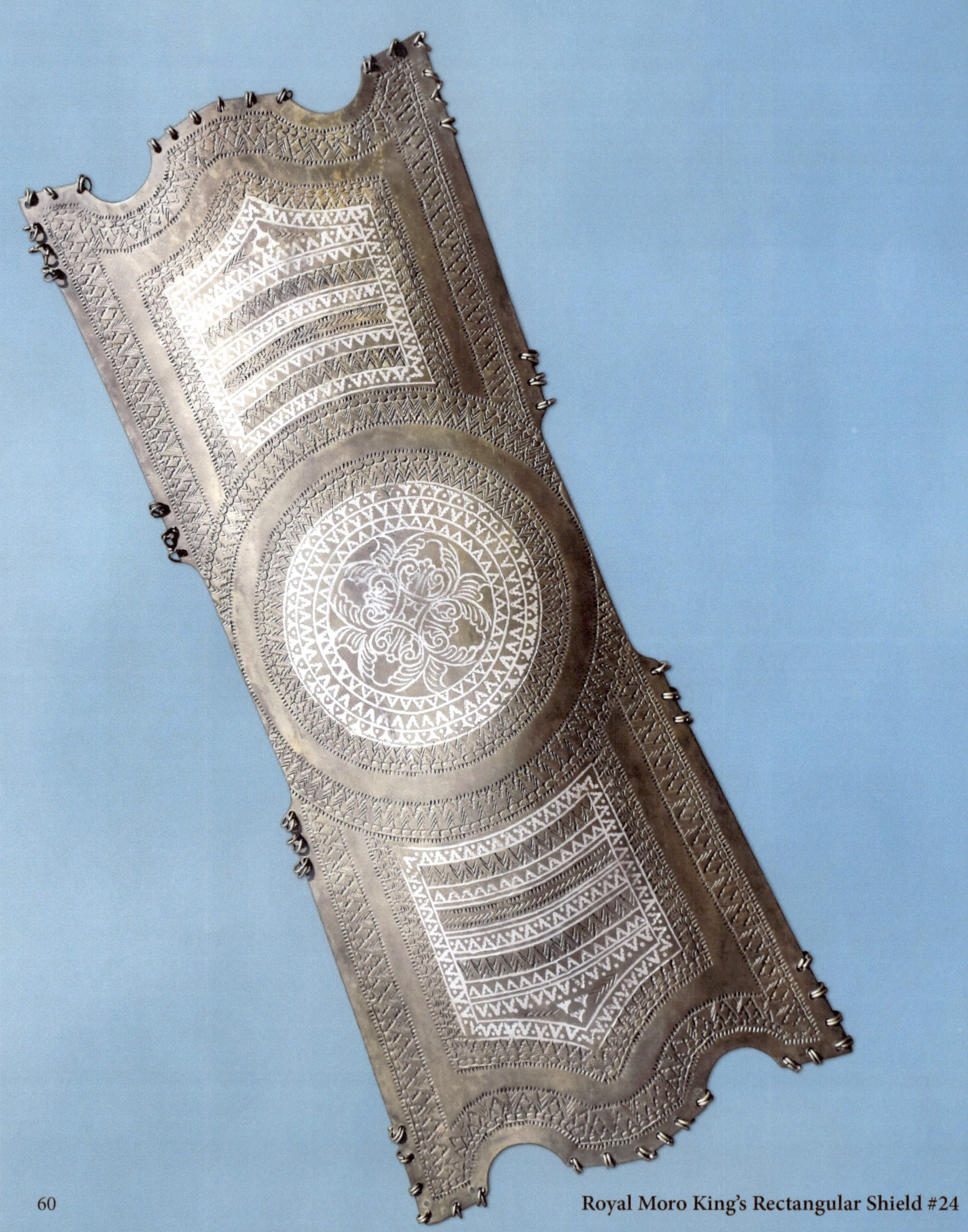

Royal Moro King's Rectangular Shield #24

ROYAL COURT ARMOR of MOROLAND MUSEUM

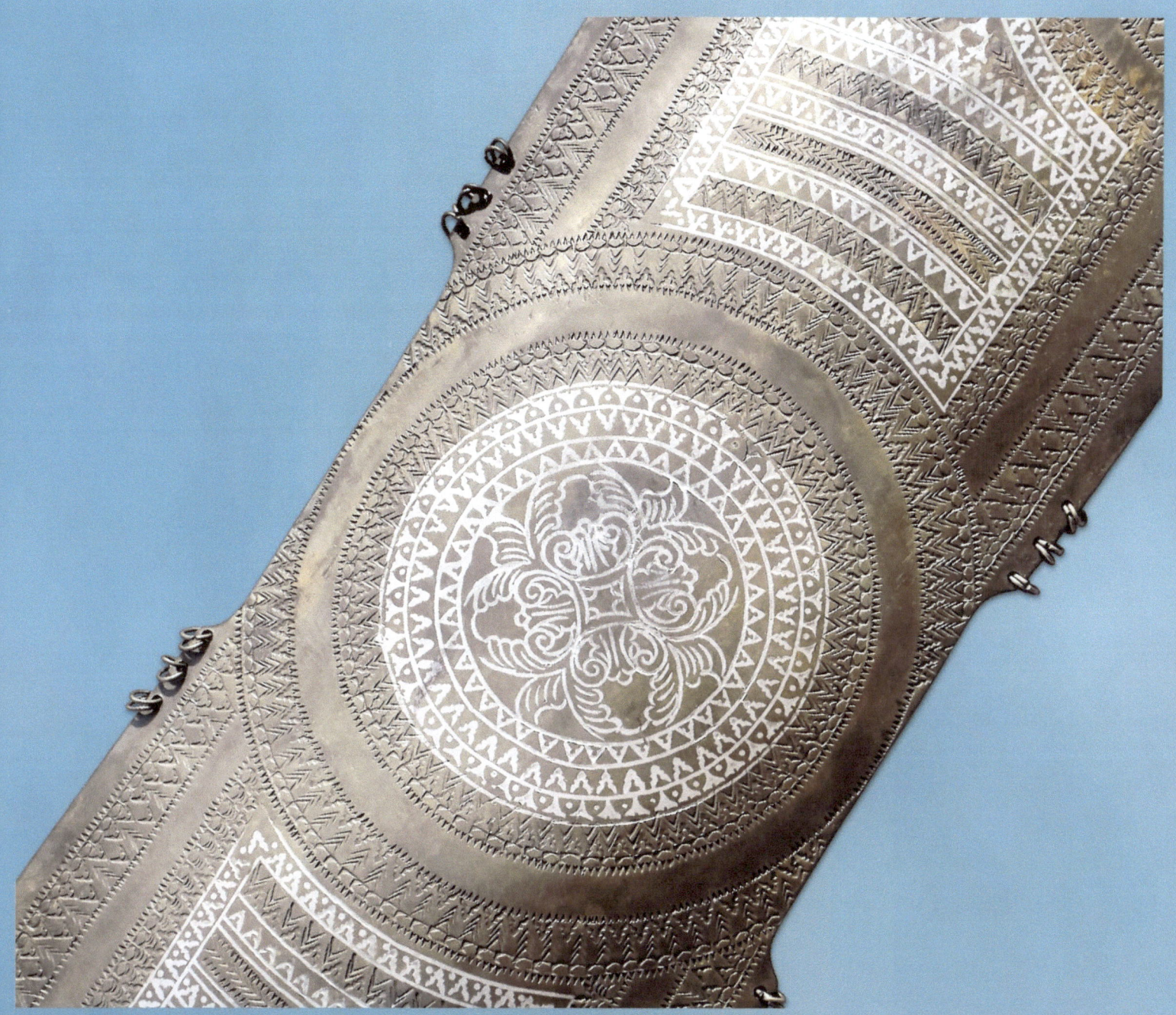

Royal Moro King's Rectangular Shield #24

Description: This type of Royal King's shield was used for land warfare. These rectangular style shields are made of bronze with ornate silver inlay patterns and has pierced metal surface with chain links attached. The inlay design shown is customary of the Muslim influence that is present in most of the Moro weapons and artifacts.

Length: 25 ins Approximate Age: 1900's
Small - Large Widths: 10 - 12 ins Condition: Museum Quality

Location Purchased: Ebay
Location Found: Lake Lanao, Mindanao, Philippines

ROYAL COURT ARMOR of MOROLAND MUSEUM

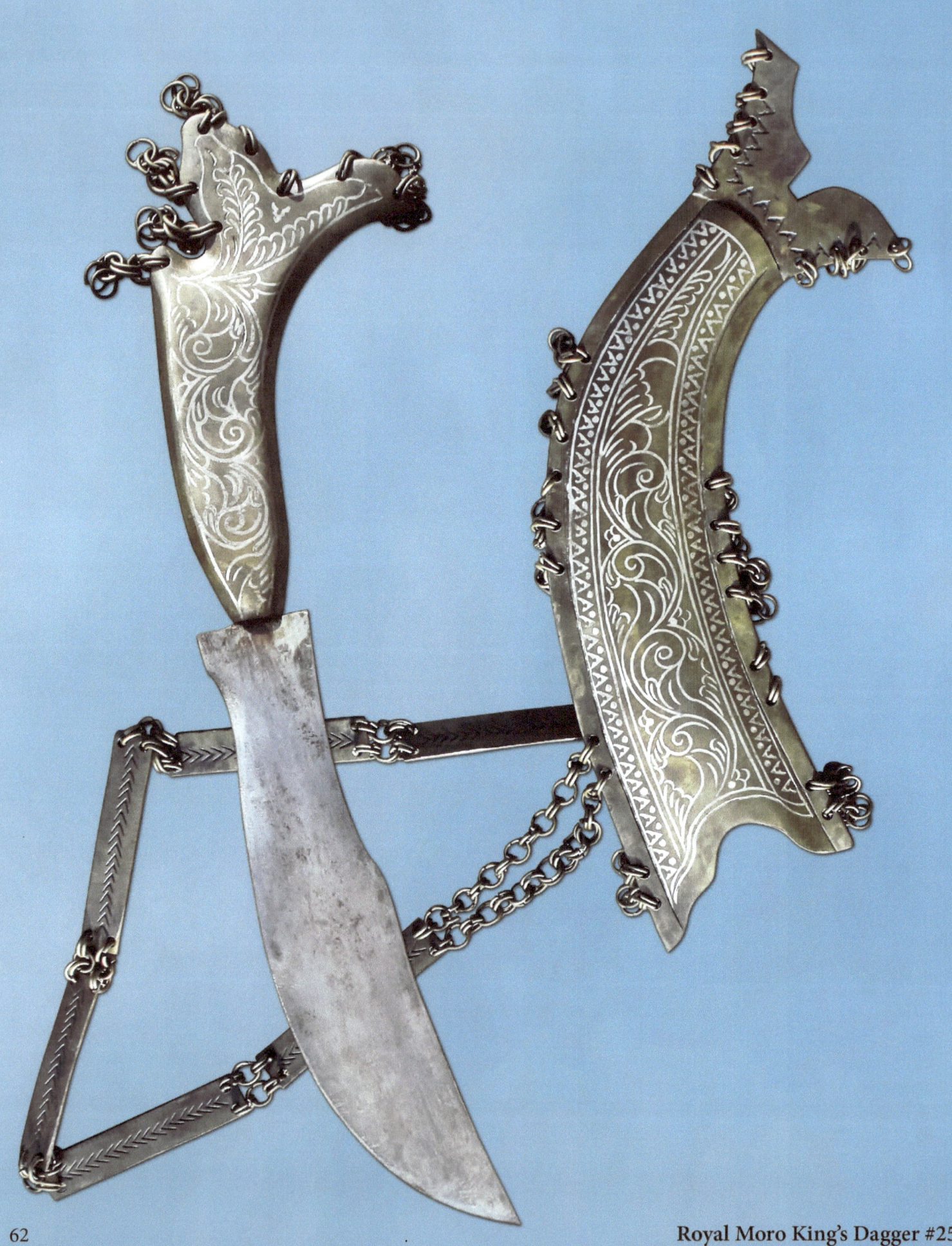

Royal Moro King's Dagger #25

ROYAL COURT ARMOR of MOROLAND MUSEUM

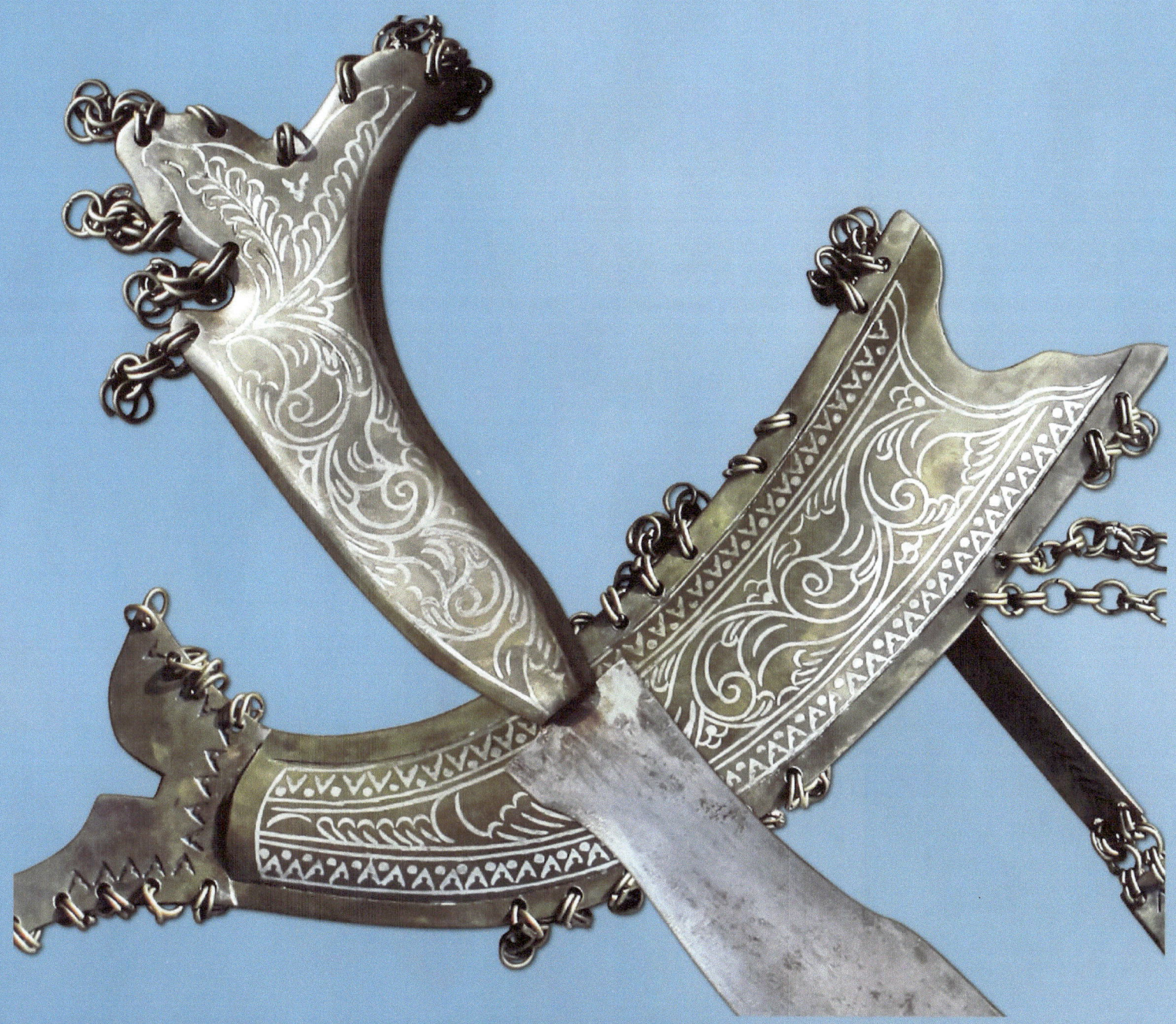

Royal Moro King's Dagger #25

Description: This royal king's knife is made of bronze with an ornate silver inlay pattern. The belt is connected by pierced metal plates attached by chain links and has links lining the edges for decoration. The design on the dagger and scabbard is of the type that is customary of the Muslim influence that is present on most of the Moro weapons and artifacts found in this area.

Total Length: 14 ins Blade: 9 ins Approximate Age: 1900's
Total Widths: 5 - 3.5 ins Condition: Museum Quality

Location Purchased: Ebay
Location Found: Lake Lanao, Mindanao, Philippines

ROYAL COURT ARMOR of MOROLAND MUSEUM

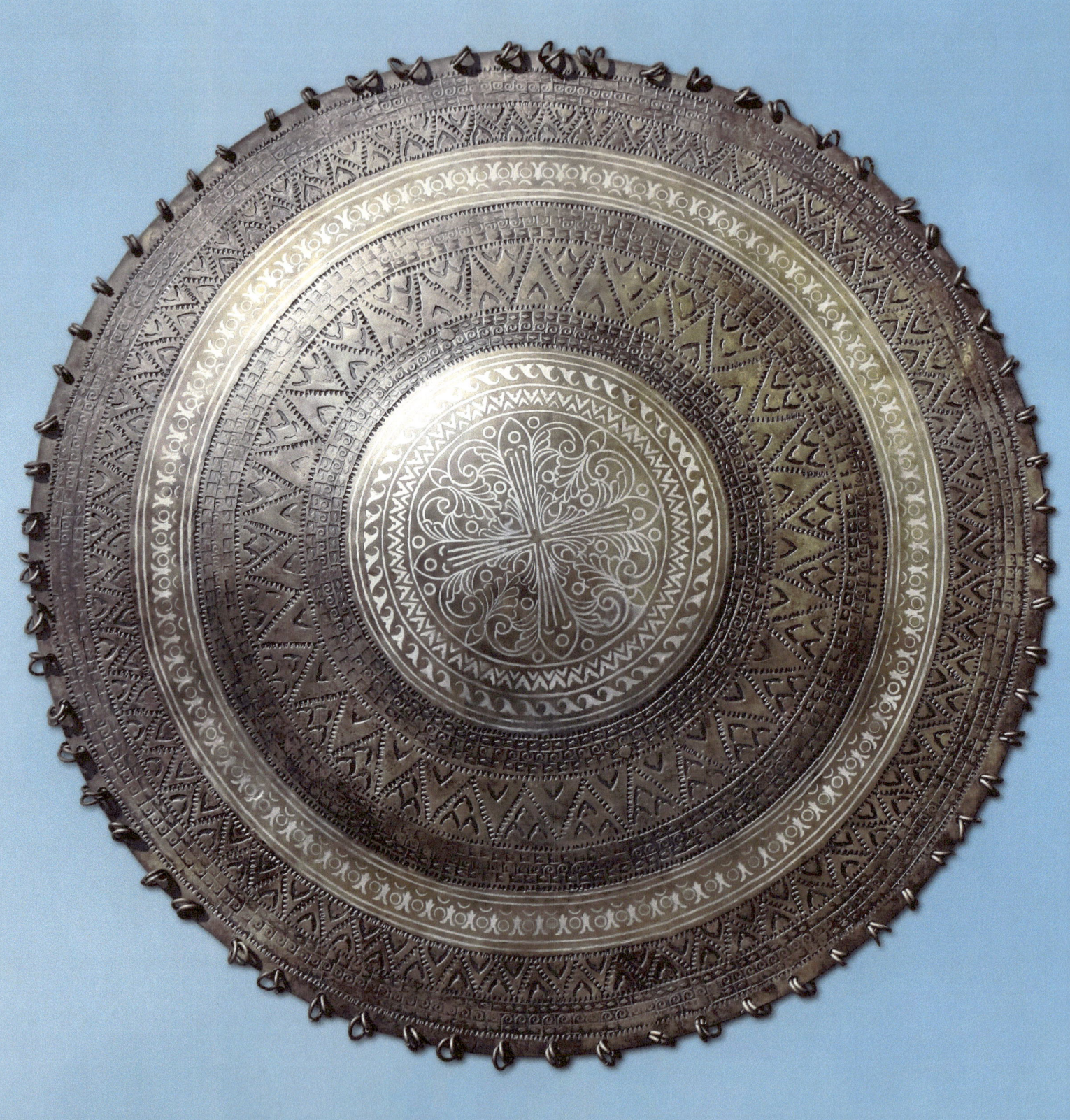

Royal Moro King's Round Shield #26

ROYAL COURT ARMOR *of* MOROLAND MUSEUM

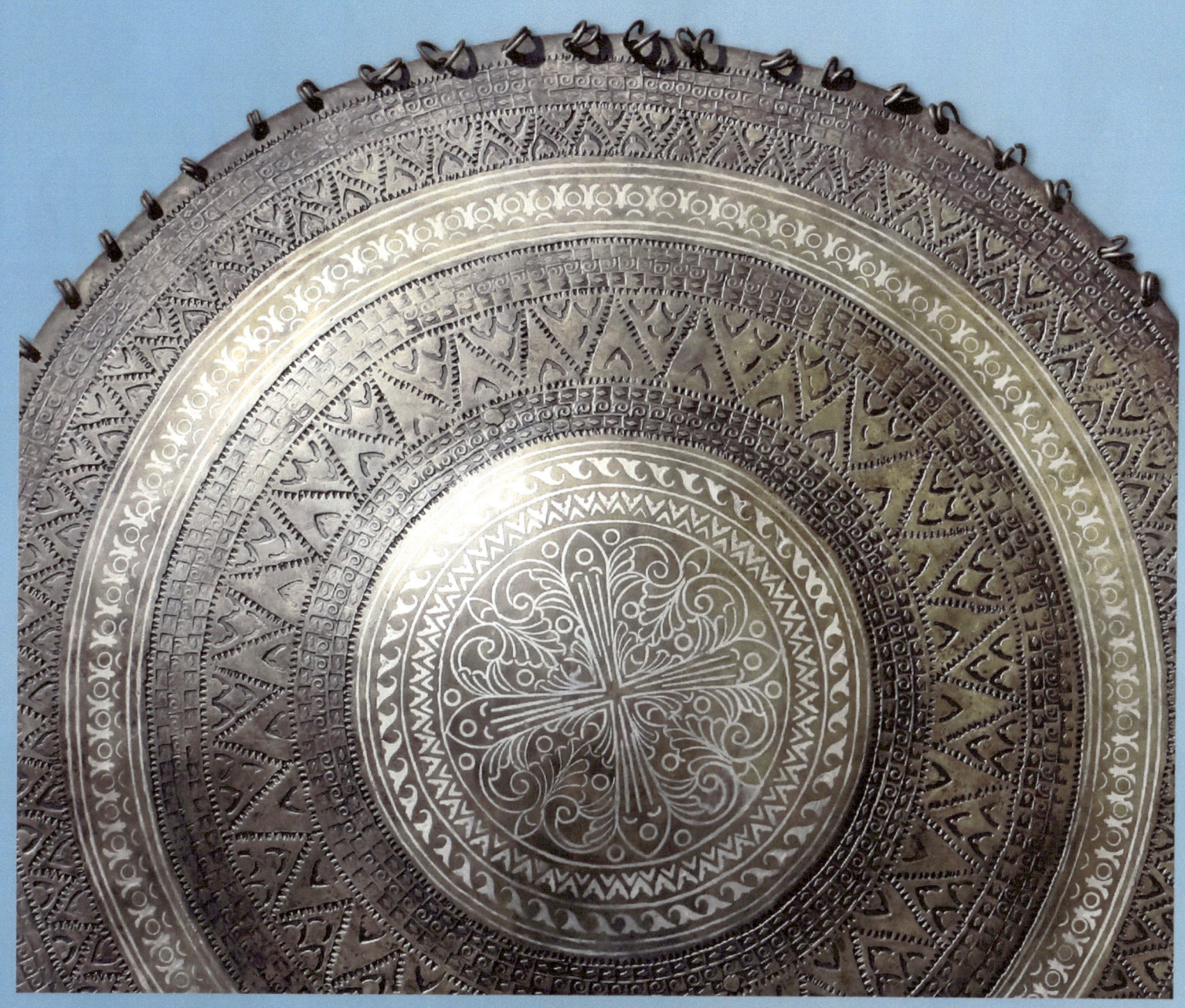

Royal Moro King's Round Shield #26

Description: This type of Royal King's shield was used for sea warfare. These round style shields are made of bronze with ornate silver inlay patterns and have pierced metal surface with chain links attached. The inlay design shown is customary of the Muslim influence that is present in most of the Moro weapons and artifacts from this area.

Circular Widths: 18 ins Approximate Age: 1900's
 Condition: Museum Quality

Location Purchased: Ebay
Location Found: Lake Lanao, Mindanao, Philippines

ROYAL MORO ARMOR
LITTLE EXTRAS

Japanese "Funny Money" Government Centavos

During World War II when the Japanese occupied the Philippines, the government issued fiat currencies in several denominations; these are known as Japanese government-issued Philippine fiat pesos/centavos (Japanese invasion money "JIM" or "Funny Money"). These little treasures were the most common of the currencies brought back by servicemen after the WWII.

By 1941 the Japanese used all of the Philippine money, coins, and U.S. currency that they captured on the island to buy supplies for their war effort. In place of the money they seized, they issued their own government paper currency. During this time, the Filipinos referred to this money as "Funny Money" as it had very little to no value. Although these paper currency bills are a vital piece of history, they still have very little or no value to them except to collectors.

By the end of the War, the currency bearing the Japanese name in circulation immediately become worthless papers.

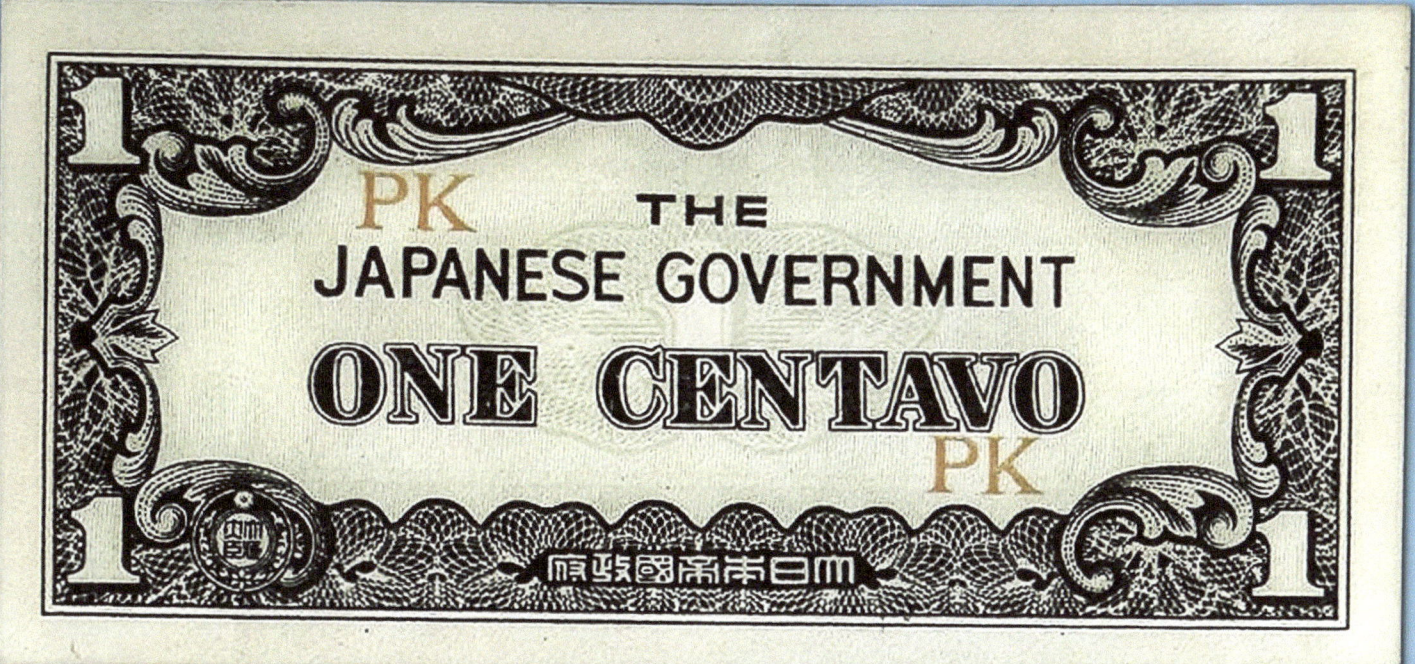

One Centavo: Front and Back

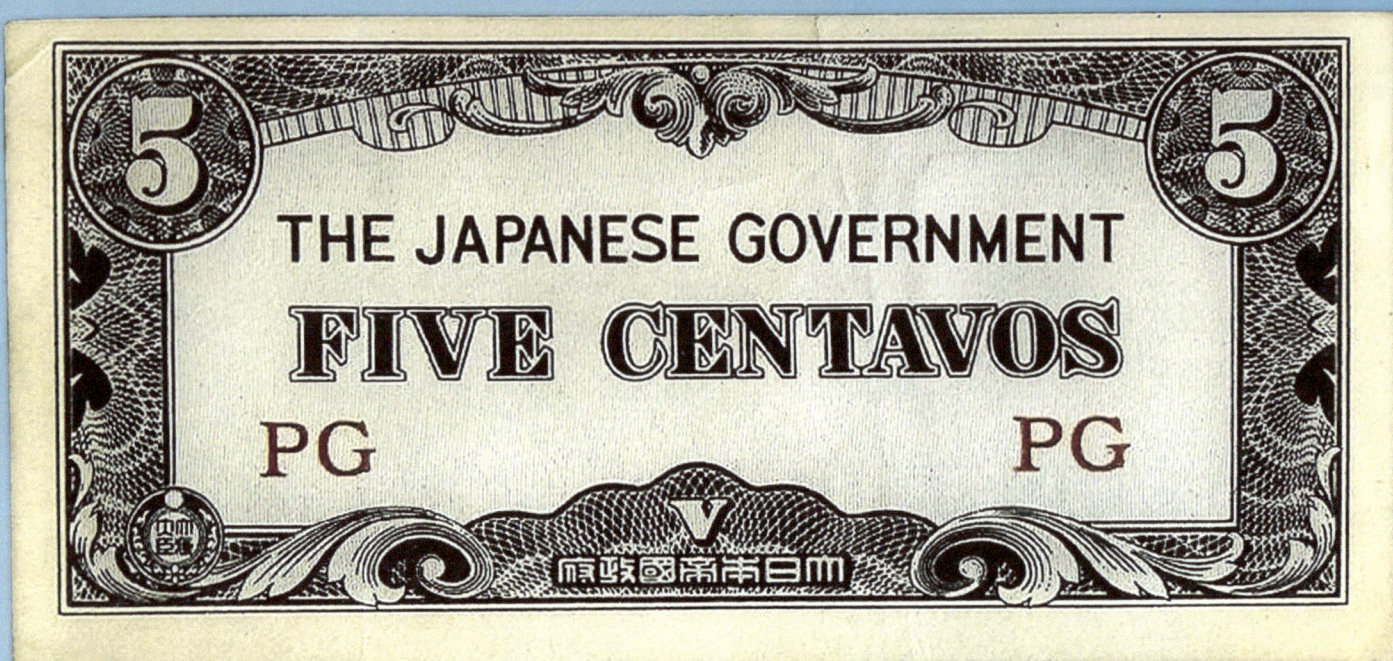

Five Centavo: Front and Back

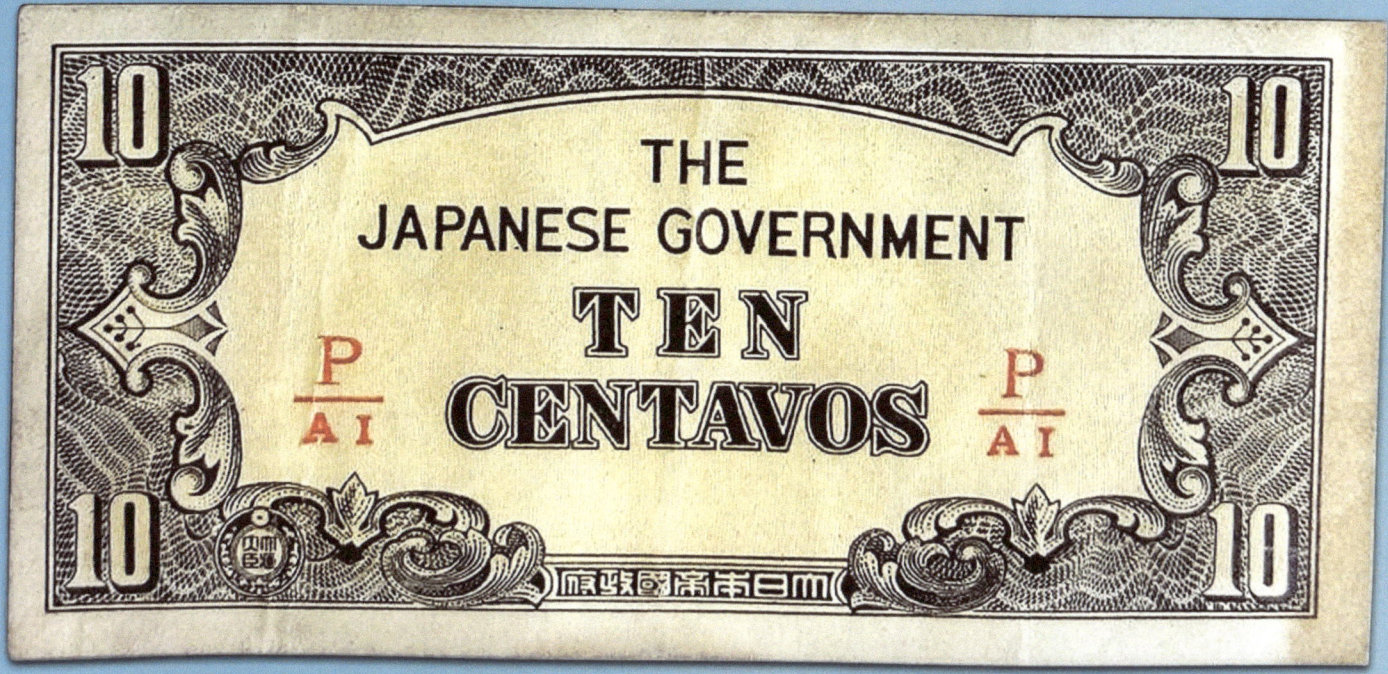

Ten Centavo: Front and Back

ROYAL COURT ARMOR of MOROLAND MUSEUM

ABOUT NEXT EDITION

field guide
Tenth edition Vol #1

Spears of Moroland Museum edition volume #01 has a variety of spears to tempt your viewing pleasure.

This pictorial field guide will be a valuable asset to use when you hunt for an addition to your collection or if you are simply curious. It will have the same style of descriptions and lots of full color pages. It will also have those wonderful extras that you like so much. This edition will have a variety of spears that are from Philippines, Malaysia and different regions within that country. The style of these spears vary from tribe to tribe and from the material they are made from. This book is a pictorial book as it contains multiple pictures of each spear and a brief description.

You will need to get the next issue to discover what other historical artifact delights await.

STATEMENTS

The writers of this book intentions were not to claim to be or imply in any way that they are experts or any kind of authority of Moroland history, art, language, or weapons, or of Philippine history, art, language, or weapons, or of any other countries history, art, language, or weapons. All of the weapons sizes and composition were an estimated guess at the time of printing.

All items are shown "as is". MOROLAND MUSEUM will not make any representation of warranty, expressed or implied, as to the marketability, fitness or condition of the items shown or described or as to the correctness of description, genuineness, attribution, size, provenance, location of origination, or period of the shown items.

The writers would like to say

THANK YOU

to those whose support and input
made this book possible.

Our Spouses, Our Children, Our Friends We would also like to thank those curious collectors who before us have preserved this part of our past and those whose skills, patience, and imagination made these items to begin with.

Conclusion

We hope this book documenting the "Royal Moro Armor from the Moroland Museum" is as much a helpful tool for you to use when you are hunting for your next big find or as an asset to your collection for visual reference purposes.

This book is the first volume that Moroland Historical Publications will publish on the Royal Moro Armor from the Moroland Museum's private armor archives. This book covers the first three sets of armor in the Moroland Museums Moro Armor from the Royal Court of Moroland collection. There are more sets of Filipino and Indonesian armor in this collection.

This is one of the largest collections of this type of Royal Moro suits of Armor (that we know of) and is most likely the very first time the "Royal Moro Armor from the Moroland Museum" has ever been displayed in this format to the public. These Armor sets are a unique part of the Filipino (Moro Tribe) craftsmanship and cultural history.

The Moroland Historical Publications team is dedicated to preserving this history by publishing books which document these artifacts for all to see and learn from. We hope you have enjoyed viewing this guide as much as our team has enjoyed creating it.

Additional Rare Books

Moroland Museum Historical Publications Book Series:

Kerises of Moroland Museum......................Book #1 on the unique Kerises (wavy blade swords) from the Moroland Museum Historical Archives, Volume #1.

Weapons of Moroland Museum....................Book #2 on the unique Weapons from the Moroland Museum Historical Archives, Volume #1.

Artifacts of Moroland Museum......................Book #3 on the unique Artifacts from the Moroland Museum Historical Archives, Volume #1.

Souvenir Weapons Plaques
of Moroland Museum....................................Book #4 on the unique Plaques from the Moroland Museum Historical Archives, Volume #1.

Igorot Shields of Moroland Museum............Book #5 on the unique Shields from the Moroland Museum Historical Archives, Volume #1.

DaYak Shields of Moroland Museum...........Book #6 on the unique Shields from the Moroland Museum Historical Archives, Volume #1.

Souvenir Weapons Plaques
of Moroland Museum....................................Book #7 on the unique Plaques from the Moroland Museum Historical Archives, Volume #2

DaYak Shields of Moroland Museum...........Book #8 on the unique Shields from the Moroland Museum Historical Archives, Volume #2.

All Moroland Museum books are available for purchase on the Amazon website and can be purchased with discount when buying in bulk.